"The camera is an instrument that teaches people how to see without a camera."

Dorothea Lange

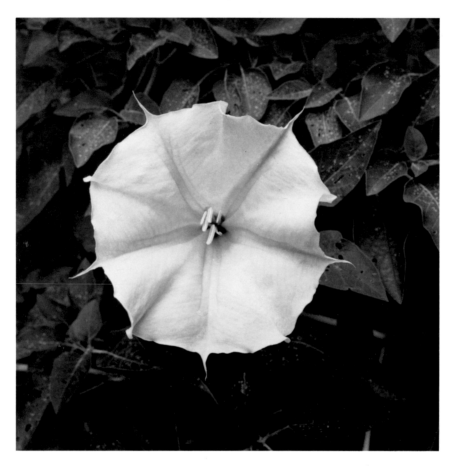

Morning Glory, Toquerville, Utah, 1953

The Photographs of *Dorothea Lange*

Keith F. Davis

with contributions by Kelle A. Botkin

HALLMARK CARDS, INC.

in association with

HARRY N. ABRAMS, INC.

This publication is one of a series from the Hallmark Photographic
Collection celebrating the history and art of photography. Previous titles
include *Harry Callahan: Photographs* (1981), *Edward Weston: One Hundred
Photographs* (1982), *Todd Webb: Photographs of New York and Paris, 1945-
1960* (1986), *Harry Callahan: New Color, Photographs 1978-1987* (1988),
George N. Barnard: Photographer of Sherman's Campaign (1990), *Clarence
John Laughlin: Visionary Photographer* (1990), *The Passionate Observer:
Photographs by Carl Van Vechten* (1993), and *An American Century of
Photography: From Dry-Plate to Digital, The Hallmark Photographic Collection*
(1995). Begun in 1964, the Hallmark Photographic Collection includes
2,700 prints by over 400 photographers. Numerous exhibitions have
been assembled from this holding and toured to museums throughout
the U.S., and in Canada, Australia, New Zealand, Great Britain, France,
and Switzerland.

Designer: Malcolm Grear Designers, Providence, Rhode Island

Tritone Separations: Thomas Palmer, Newport, Rhode Island

Printer: Meridian Printing, East Greenwich, Rhode Island

Library of Congress Catalog Card Number: 95-79156
ISBN 0-8109-6315-9

Published in 1995 by Hallmark Cards, Inc., Kansas City, Missouri

Distributed by Harry N. Abrams, Incorporated, New York
A Times Mirror Company

Printed and bound in the United States of America

Table of Contents

Introduction and Acknowledgments

Dorothea Lange is widely recognized as one of the most eloquent and original photographers in the medium's history. The continuing importance of her work stems, in part, from its insistent duality. At once documentary and interpretive in intention, public and private in meaning, Lange's photographs reveal truths of both society and the soul. To casual viewers, the formal complexity and emotional range of Lange's vision are masked by the apparent simplicity of her photographs—their directness and clarity. In truth, she applied the tools of a dispassionate, documentary approach to forge a deeply personal artistic vision. This union of objective and subjective concerns was never reduced to a formula. Instead, it reflected the dynamic relationship in Lange's work between fact and feeling, observation and engagement. Her son, Daniel Dixon, has evoked the underlying complexity of Lange's character and vision with eloquent clarity: "My mother seemed simple, gentle, and direct. She was in truth intricate, subtle, and compelling."[1]

Clues to the nature and meaning of Lange's work are contained in the story of her life. Born in 1895, in Hoboken, New Jersey, her childhood was marked by unhappiness and a sense of alienation. At the age of seven, a bout with polio left her with a lifelong limp. While far from incapacitating, this handicap set Dorothea apart from her peers. It also gave her a deep sympathy for the plight of other outsiders, and to the expressive language of the body. Her father deserted the family when she was twelve, and Dorothea's teenage years, spent in the household of her maternal grandmother, were marked by conflict and rebellion. Although she had not previously owned or used a camera, Dorothea made a firm decision upon graduating from high school: she would be a photographer. Her training, through apprenticeships in several New York portrait studios, was of an eminently practical and commercial nature. Notably, however, she also attended a seminar at Columbia University taught by the great Pictorialist photographer Clarence H. White.

Lange's professional life began in 1918, when she left New York for San Francisco. She opened her own studio a year later and soon achieved suc-

cess producing highly competent—if not unusually inspired—portraits of the city's social elite. In 1920, she married Maynard Dixon, a noted artist and illustrator nearly twenty years her senior. Dixon's populist sensibilities and dedication to his art inevitably influenced her, although Lange spent the next dozen years attending to her portrait business and raising a family.

In the early 1930s, Lange's growing dissatisfaction with these roles was catalyzed by the political and economic trauma of the Depression. Motivated by the social turmoil around her, Lange took her camera from the studio into the street, tentatively at first, and then compulsively. She recorded the despair and uncertainty of the urban unemployed and the grinding poverty of migrant families living in crude roadside camps. Her photographs are at once bluntly factual and deeply sympathetic. While Lange recorded innumerable scenes of destitution, she consistently evoked the resilience, faith, and determination of her subjects. As a result, her photographs celebrate the basic strength of the American character—the strength required to carry millions of people through this long, frightening chapter in the nation's history.

The remarkable power of Lange's pictures reflects the deep meaning these subjects held for her. Lange's sympathy for the average man grew naturally from the populist political views she shared with Dixon. It also seems clear that her interest in the unemployed and homeless represented a conscious rejection of her former life as the maker of genteel portraits for the most comfortable strata of San Francisco society. On a deeper level, the themes of the body, and of the bonds of family and community, lie at the heart of Lange's work. As one who felt irrevocably shaped by the demands and limitations of her own body, Lange was minutely attentive to the physical expression—in gesture and stance—of the psychological and social forces of the era.[2] In their slackness and slow surrender to gravity, Lange's subjects poignantly convey the humiliation of poverty and the erosion of identity that comes with unemployment. Underlying her work is a vision of rootlessness and isolation, tempered by a hopeful celebration of the fragile, imperfect, but enduring bonds of kin-

ship and community. In important ways, of course, this complex and bittersweet view was a product of Lange's own experience: her broken family life, unhappy childhood, and discomfort in the traditional roles of wife and mother. The urgency and depth of her photographs are derived precisely from this union of social and personal concerns.

By the close of 1935, Lange's life had changed significantly. Her amicable but distant marriage with Dixon was ended, and a new one begun with Paul S. Taylor, a professor of economics at the University of California-Berkeley. Taylor, an ardent New Deal progressive, was a specialist in the issues of farming and migratory labor. His broad grasp of history, economics, and politics powerfully influenced Lange's outlook, sharpening her understanding of the subjects she recorded and of the impact and utility of her pictures. On the other hand, Lange's unparalleled visual acuity lent specificity and emotional weight to Taylor's statistics and prose. Their important collaborative book, *An American Exodus: A Record of Human Erosion* (1939), stands as eloquent testimony to the effectiveness of their professional relationship.

It was also in 1935 that Lange was asked to join the photographic staff of the Resettlement Administration (later renamed the Farm Security Administration). This position, which she held (with a few interruptions) through 1939, provided the ideal opportunity to merge two seemingly disparate concerns: personal, artistic expression and social and political activism. Lange traveled widely in this period, photographing throughout California, and in the South, Southwest, and Plains States. Her resulting pictures constitute a major portion of the F.S.A.'s vast record of Depression-era America—an archive that has strongly shaped our collective memory of the period.

After her tenure with the F.S.A., Lange's photographic career was disrupted by illness and family obligations. But, despite the intermittent nature of this later effort, she continued to make powerful images. During World War II, Lange worked on such important subjects as the internment of West Coast Japanese-Americans. In the 1950s, she recorded a variety of topics, including small town life in Utah and Ireland, the California legal system, the

environmental consequences of development, and the gentle rhythms of everyday life. Between 1958 and 1963, she accompanied Taylor abroad, photographing in Asia, Egypt, and South America.

While Lange's later work embraces a variety of subjects, it traces a clear trajectory from public to private concerns. In the early 1940s, she was commissioned by official agencies to record subjects of broad social or political importance. In the early 1950s, she tended to work independently, producing photoessays on themes of her own choice and then attempting (with varying success) to find appropriate public outlets for them. Some were featured in *Life* and *Aperture*; others went unpublished. In the last decade of her life, the majority of Lange's work was resolutely private in both subject and mood. She produced close, intimate views of people she knew very well—her family and friends—as well as poetic vignettes of cultures that were completely alien to her. Surprisingly, perhaps, the work from these utterly dissimilar realms is remarkably consistent in feeling. In both cases, Lange sought the physical and emotional essentials of life: nurture, sorrow, joy, the weight or grace of the body, the ability to see and to dream. There is little hint in these late pictures of specific social contexts or political causes. Instead, they focus on the most primal and universal aspects of human life.

As her late work so poignantly reveals, the ultimate subject of Lange's photography was as much herself as the world around her. Her vision of the people and events of her time was always flavored, informed, and shaped by the complexity of her own experience and emotional life. It is in this mercurial synthesis of analysis and intuition, fact and poetry, that her greatness lies.

Lange's work is usually categorized as "documentary." However, this term seems insufficiently supple to describe her real achievement. Certainly, her photographs are enormously important *as* documents, and Lange herself greatly valued the idea of objective description—the photograph as incontrovertible fact. For many years, she kept a quote by Francis Bacon posted prominently on her darkroom door: "The contemplation of things as they are...is in itself a nobler thing than a whole harvest of invention." Lange both adhered to these words and transcended them. The things she contemplated included the people, places, and events visible to so many others of her time, as well as the memories, ideas, hopes, and ambitions known, ultimately, only to her. In a way that defies precise analysis, Lange's work represents a synthesis of her outer and inner worlds, the things she saw and the things she felt, things known and things imagined. Lange's brilliance lies in her sensitivity—and truthfulness—to both these realms of experience, her deep respect for the world and her passionate engagement with it. Her struggle to forge a meaningful artistic whole from the turmoil and complexity of her life was, indeed, a profoundly noble thing.

This book, and the traveling exhibition which accompanies it, together commemorate the centennial of Dorothea Lange's birth. Most of the prints reproduced in this volume were given by Lange to members of her extended family. They were subsequently acquired by the Hallmark Photographic Collection in the early 1990s. This selection of 85 prints is not meant, of course, to be considered exhaustive. Rather, it is hoped that by encompassing the full breadth of her influential career, this volume confirms Lange's historical stature while expanding our understanding of her subtle, incisive vision. This book deliberately emphasizes a "first-person voice" by supplementing the reproductions with passages of Lange's own words and those of some of her subjects. Through this union of pictures and text, the documentary and the personal, a richer understanding of the intentions and meanings of Lange's work may be achieved.

This publication, and the accompanying exhibition, could not have been accomplished without the generosity and assistance of many people. Kelle A. Botkin's knowledge of Lange's life and work was enormously helpful throughout the course of this project. In addition to assisting with the research on the prints reproduced here, Kelle prepared the first draft of this volume's bibliography and chronology. Grateful acknowledgment is

extended to Edwynn Houk, of Houk Friedman Gallery in New York, for coordinating the acquisition of most of the works reproduced in this catalogue, and for related advice and assistance. Deep thanks are extended to the members of the Lange family, particularly to Daniel Dixon and John Dixon, for their support of this exhibition and publication, and their willingness to answer a variety of questions on their mother's work. I am also grateful to Susan Ehrens and Leland Rice for so generously sharing their knowledge of—and enthusiasm for—Lange. Drew Johnson, of the Oakland Museum, was most helpful in facilitating research in the museum's Lange archive. The advice and published work of the Oakland Museum's senior curator of photography, Therese Heyman, is also gratefully acknowledged. Thanks are also extended to Mrs. Willa K. Baum of the Regional Oral History Office of the Bancroft Library, University of California-Berkeley, for permission to quote from Suzanne Riess's interview with Lange.

The quality of this volume is a result of the talents of many people: the superb tritone separation work of Thomas Palmer, the thoughtful design of the staff of Malcolm Grear Designers, and the precision of the pressmen and staff of Meridian Printing. For coordinating the distribution of this book, thanks are also extended to Margaret L. Kaplan of Harry N. Abrams, Inc.

At Hallmark, thanks go once again to Mike Pastor for his excellent reproduction transparencies, to Ken Jacobs and his staff for retouch assistance, to Jaye Wholey for typesetting, to Rich Vaughn for so ably overseeing the entire production process, and to Pat Fundom and Nicki Corbett for their invaluable help in matters large and small. And, as always, I deeply appreciate the ongoing support and encouragement of William A. Hall, Irvine O. Hockaday, and Donald J. Hall.

Keith F. Davis
Fine Art Programs Director
Hallmark Cards, Inc.

[1] Elizabeth Partridge, ed., *Dorothea Lange: A Visual Life* (Washington, D.C.: Smithsonian Institution Press, 1994), p. 162.

[2] This theme forms the subject of Sally Stein's insightful essay in Elizabeth Partridge, ed., *Dorothea Lange: A Visual Life*.

"For me documentary photography is less a matter of
subject *and more a matter of* approach. *The impor-*
tant thing is not what's *photographed, but* how....
My own approach is based upon three considerations.
First—hands off! Whatever I photograph, I do not
molest or tamper with or arrange. Second—a sense
of place. Whatever I photograph, I try to picture as
part of its surroundings, as having roots. Third—
a sense of time. Whatever I photograph, I try to show
as having its position in the past or in the present.
But beyond these three things, the only thing I keep
in mind is that—well, there it is, that quotation,
pinned up on my darkroom door:

The contemplation of things as they are
without error or confusion
without substitution or imposture
is in itself a nobler thing
than a whole harvest of invention.
FRANCIS BACON."

"I was a portrait photographer in San Francisco... I struggled hard with it, and some of my longest, hardest working years were those years, up to the limit of my strength. I worked to maintain that place. It was quite a venture because it was a rather expensive place, and I had what they call the cream of the trade... I enjoyed every portrait that I made in an individual way, but it wasn't really what I wanted to do. I wanted to work on a broader basis..."

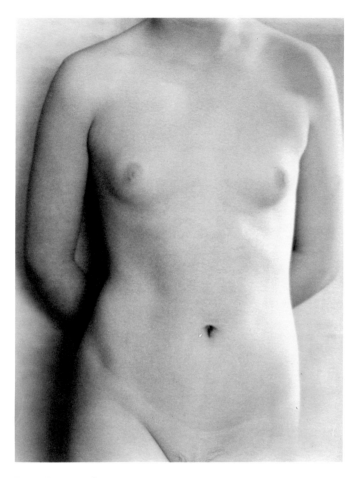

Torso, San Francisco, 1923

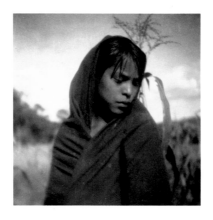

Young Indian Girl, Southwest, ca. 1930

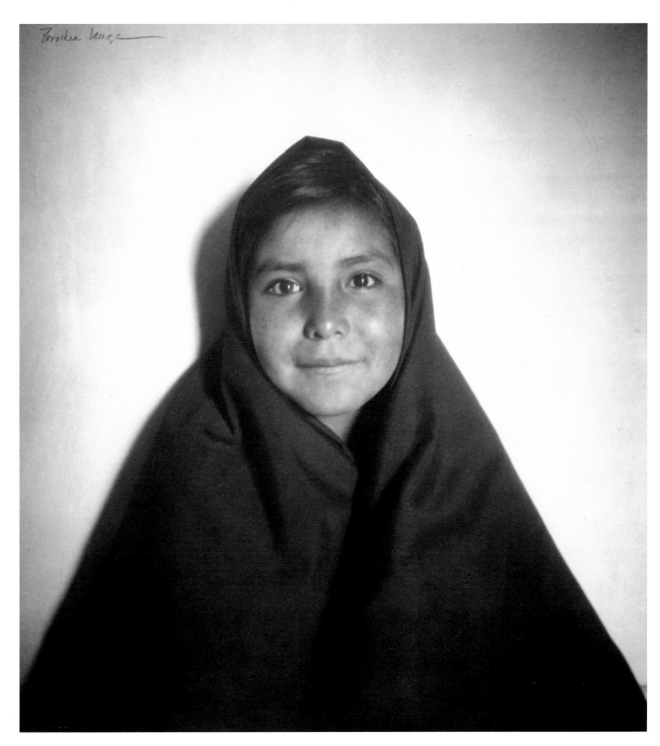

Portrait of a Young Hopi Indian, New Mexico, ca. 1923

"We went into a country which was endless, and timeless, and way off from the pressures that I thought were part of life. The earth, and the heavens, even the change of seasons, I'd never really experienced until that time."

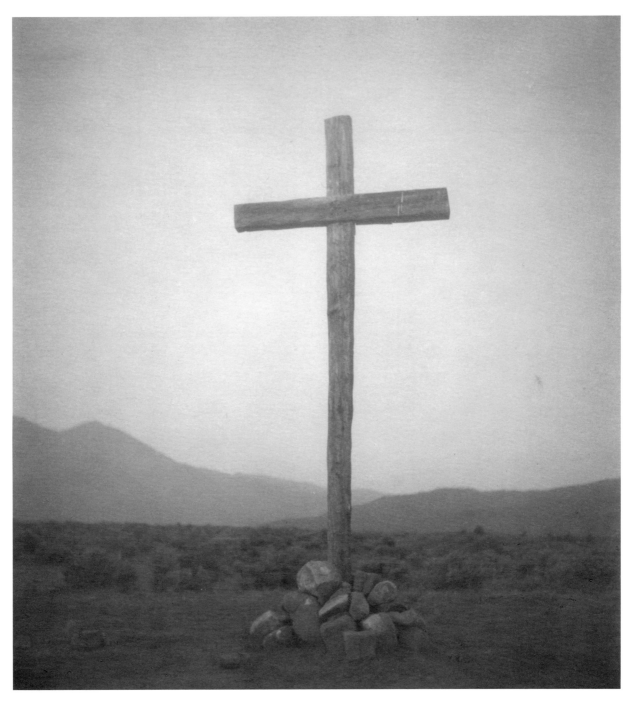

New Mexico, ca. 1931

"That period in Taos was a very good time for me. I learned many enriching things.... I photographed once in a while when I could, but just a little...

"When we came back [to San Francisco] we were confronted immediately with the terrors of the Depression.... Not that we didn't have enough to eat, but everyone was so shocked and panicky. No one knew what was ahead."

"There in my studio on Montgomery Street I was surrounded by evidence of the Depression. I was on the corner where the sun came in and I remember well standing at that one window and just watching the flow of life... That sunny south window...had a shelf and every day I made solar proofs of current portraits on that shelf... With those proofs, while the image deepens and darkens you have a moment's respite. So I looked out the window into the street...

"I watched an unemployed young workman coming up the street. He came to the corner, stopped, and stood there for a little while. Behind him were the waterfront and the wholesale districts; to his left was the financial district; ahead was Chinatown and the Hall of Justice; to his right were the flophouses and the Barbary Coast. What was he to do? Which way was he to go?

"The discrepancy between what I was working on in the printing frames and what was going on up the street was more than I could assimilate. I knew that if my interests in people were valid, I would not only be doing what was in those printing frames...

"I was compelled to photograph as a direct response to what was around me."

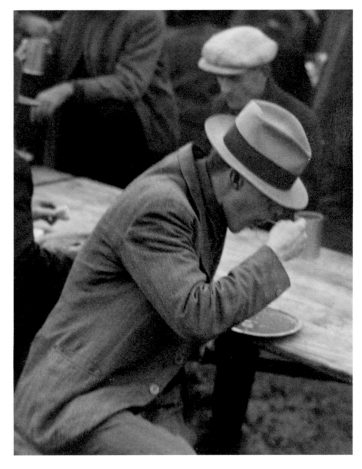

White Angel Breadline, San Francisco, 1933

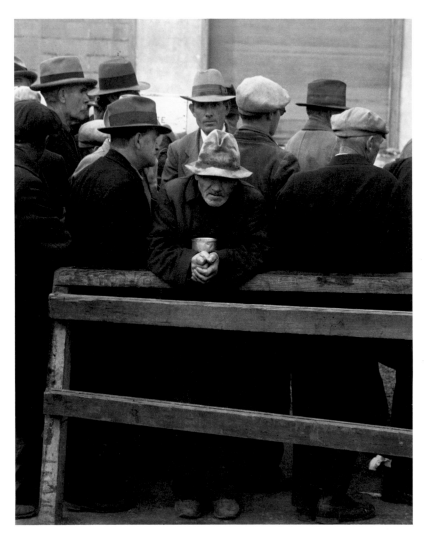

White Angel Breadline, San Francisco, 1933

"*There are moments such as these when time stands still and all you do is hold your breath and hope it will wait for you. And you just hope you will have time enough to get it organized in a fraction of a second on that tiny piece of sensitive film. Sometimes you have an inner sense that you have encompassed the thing generally. You know then that you are not taking anything away from anyone: their privacy, their dignity, their wholeness.*"

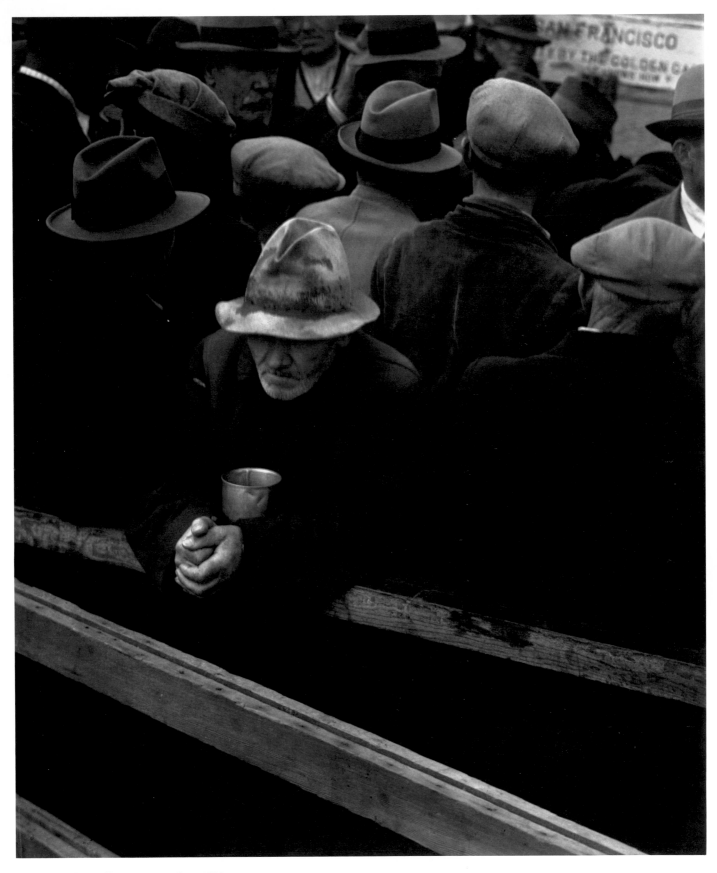

White Angel Breadline, San Francisco, 1933

"I realize more and more what it takes to be a really good photographer. You just go in over your head, not just up to your neck."

"I assigned myself the task of photographing the May Day demonstrations at Civic Center. I knew there was a great deal of trouble abroad, and that there were going to be demonstrations at the Civic Center by the unemployed, and I said to myself, 'I can't afford to do this and I shouldn't, but I want to.'"

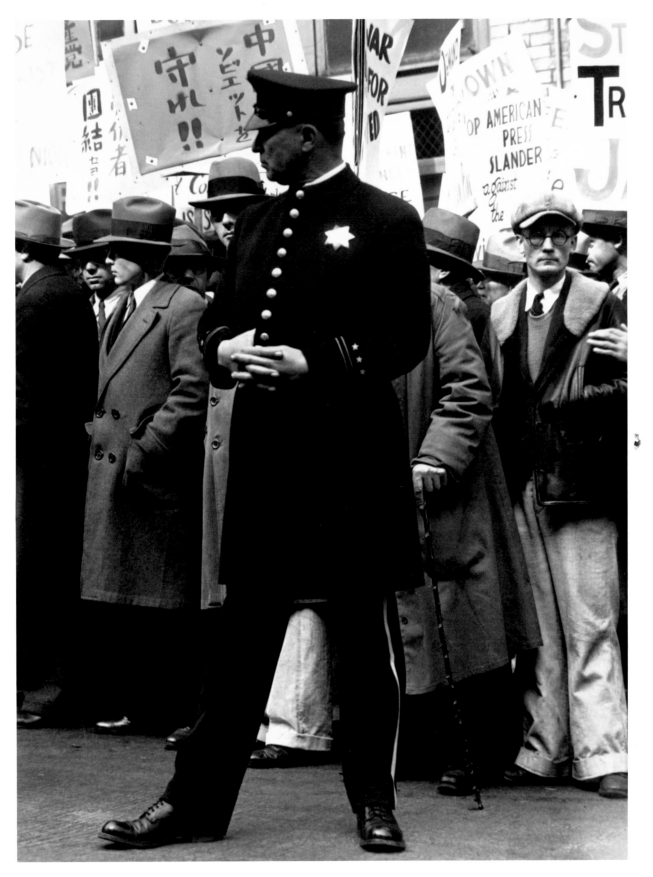

Street Demonstration, San Francisco, 1933

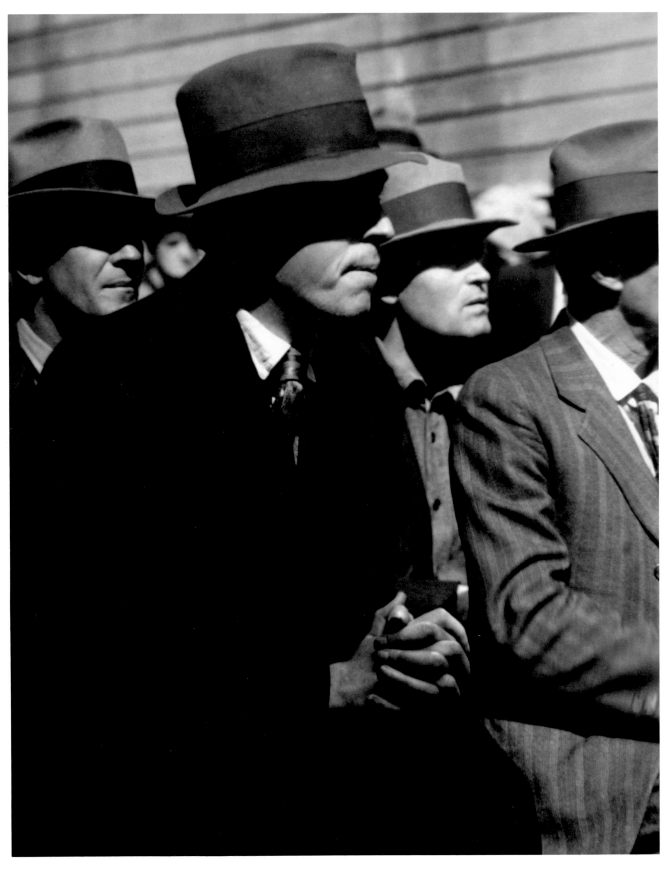

Street Meeting—The Audience Listens, San Francisco Waterfront Strike, 1934

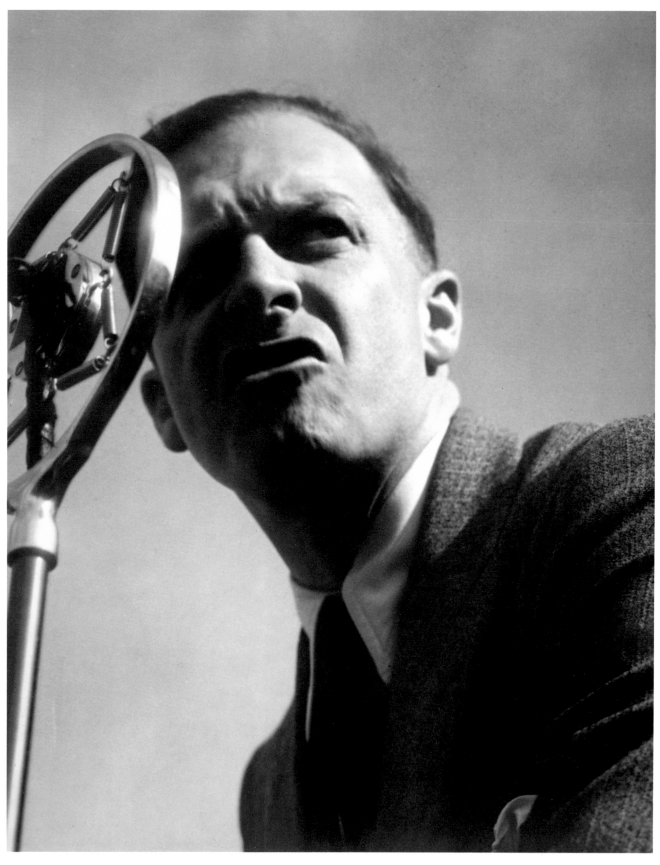

May Day Demonstrations, San Francisco Civic Center, 1934

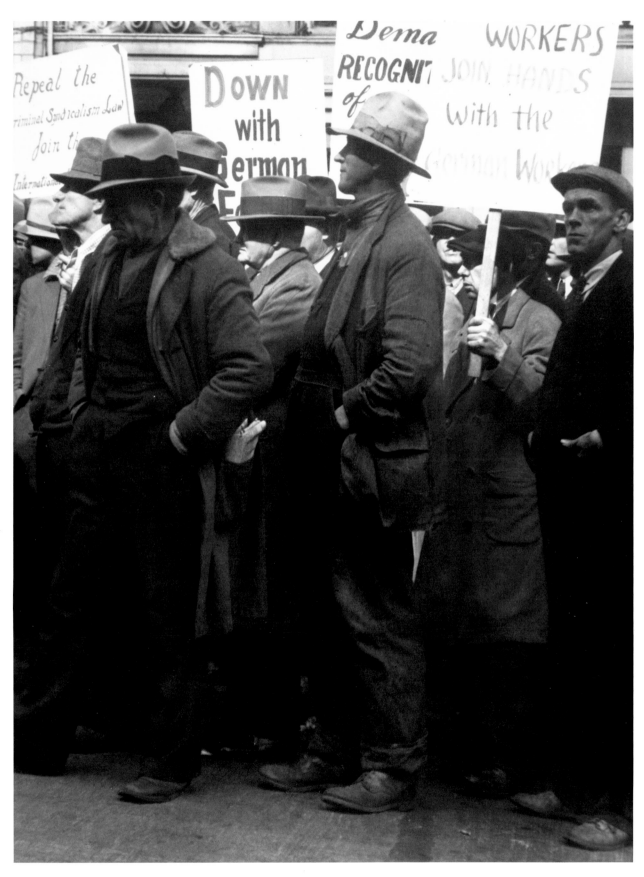

Demonstrators, ca. 1934

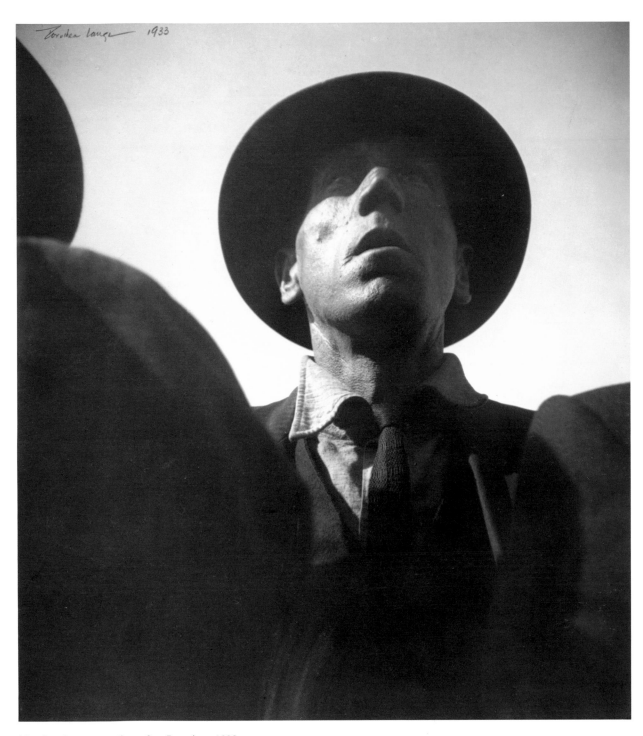

May Day Demonstrations, San Francisco, 1933

"By then I'd begun to get a much firmer grip on the things I really wanted to do in my work. This photograph of the man with his head on his arms, for instance—five years earlier, I would have thought it enough to take a picture of a man, no more. But now, I wanted to take a picture of a man as he stood in his world—in this case, a man with his head down, with his back against the wall, with his livelihood, like the wheelbarrow, overturned."

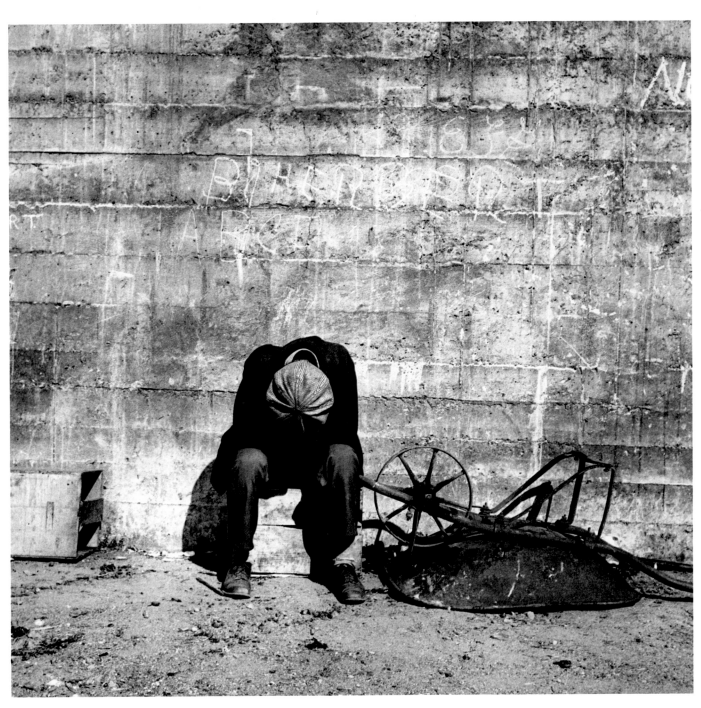

Against the Wall, San Francisco, 1934

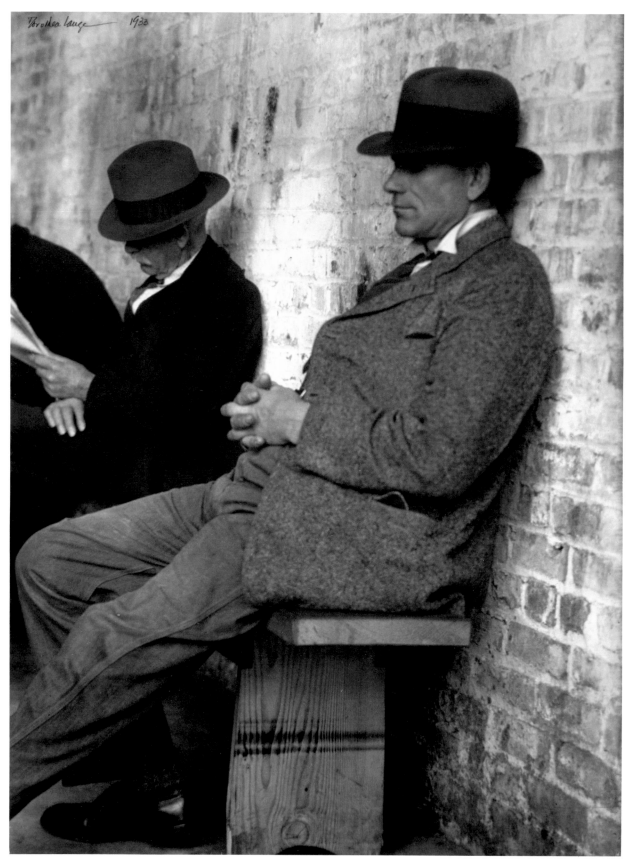

Unemployed, Howard Street, San Francisco, 1934

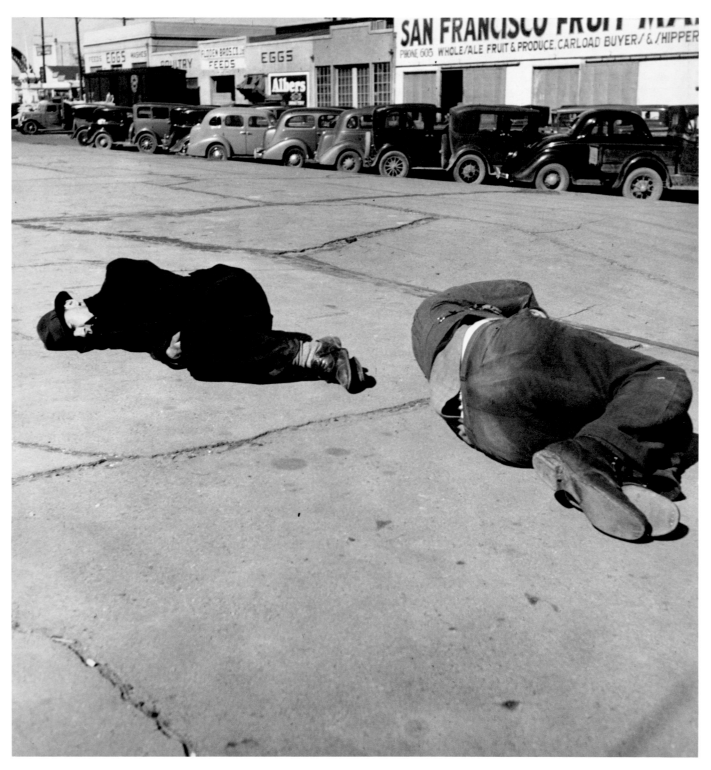

Scene Along "Skid Row," Howard Street, San Francisco, February 1937

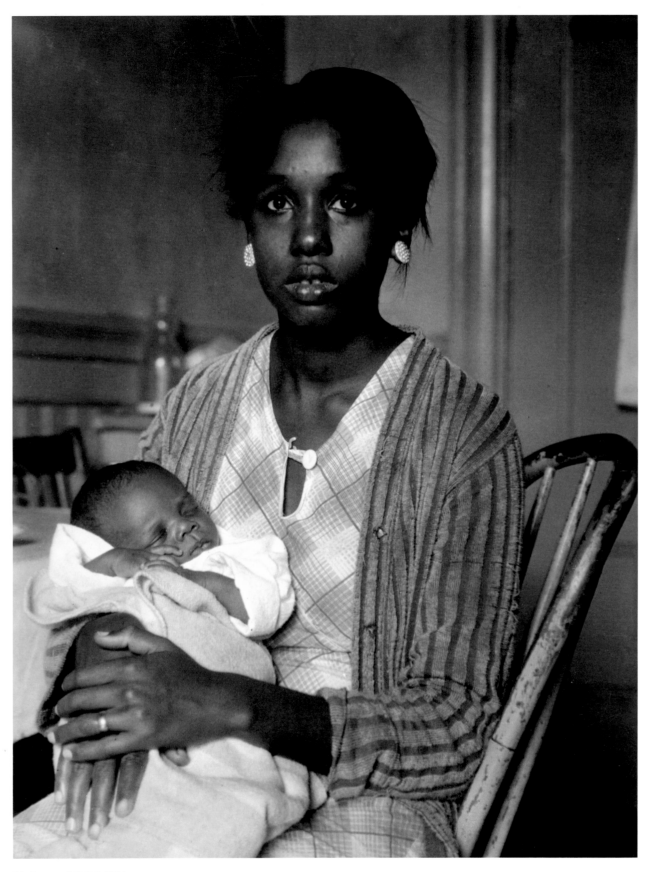

Mother and Child, 1934

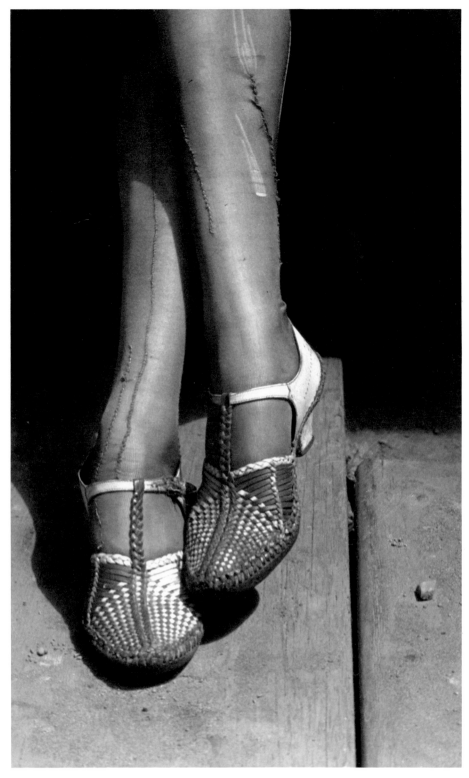

A Sign of the Times—Depression—Mended Stockings, Stenographer, San Francisco, 1934

"The country's in an uproar now—it's in bad shape. The people's all leaving the farm. You can't get anything for your work, and everything you buy costs high. Do you reckon I'd be out on the highway if I had it good at home?"

On U.S. 80 near El Paso, June 1938

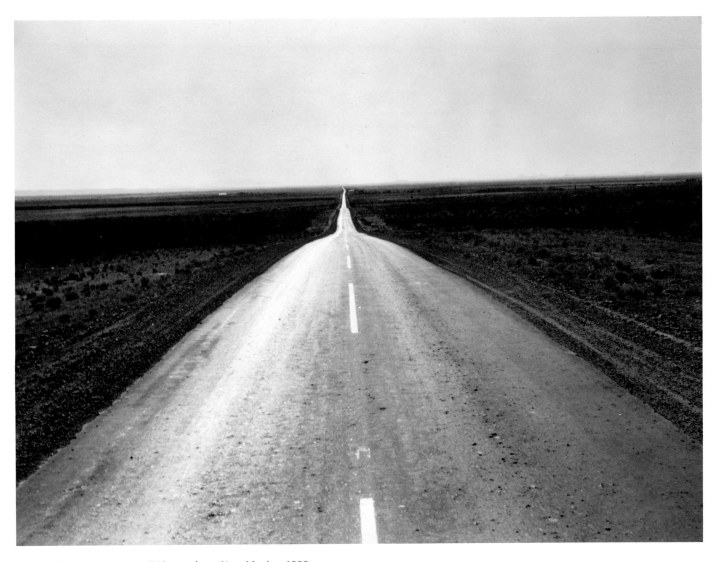

The Road West, U.S. Route 54 in southern New Mexico, 1938

"They keep the road hot a goin' and a comin'."

"They've got roamin' in their head."

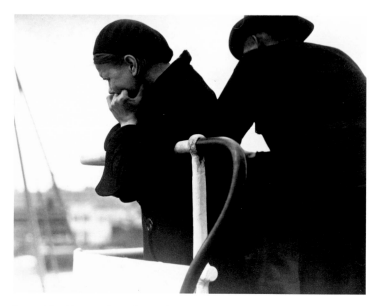

Bound for Matanuska Colony, Alaska, May 1935

"No, I didn't *sell* out back there. I *give* out."

Refugee in California

Example of self-resettlement in California. Oklahoma farm family on highway between Blythe and Indio, California. Forced by the 1936 drought to abandon their farm, they set out with their children to drive to California. Picking cotton in Arizona for a day or two at a time gave them just enough for food and gas to continue. On the day this photo was taken, they were within a day's travel of their destination—Bakersfield, California. Their car had broken down en route, and was abandoned.

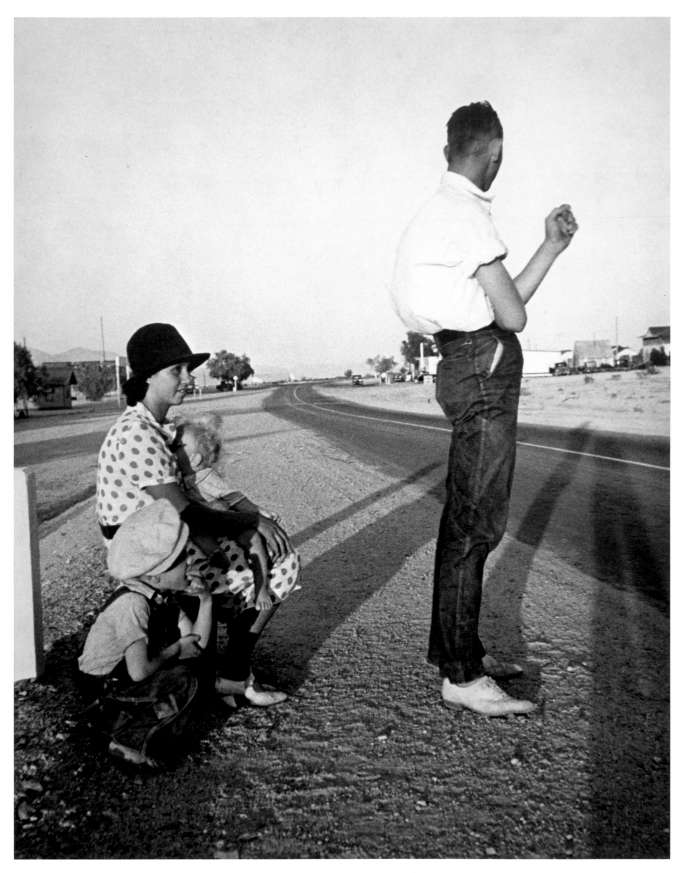

Oklahoma Family on highway between Blythe and Indio, California, August 1936

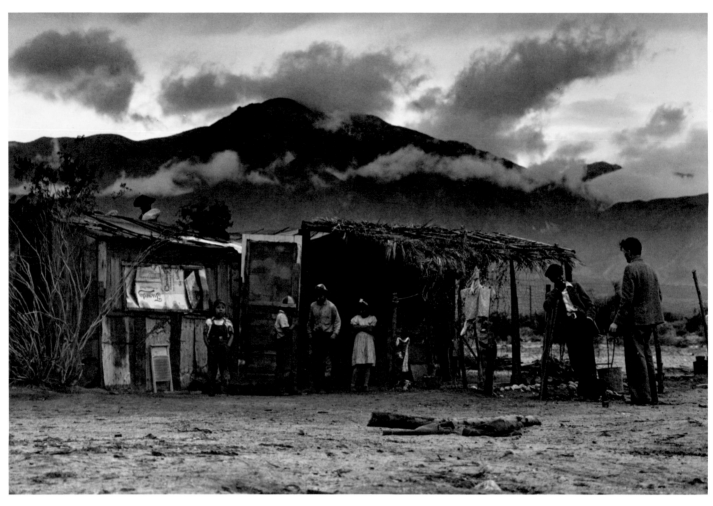

Paul Taylor in Migrant Labor Camp, Coachella Valley, 1935

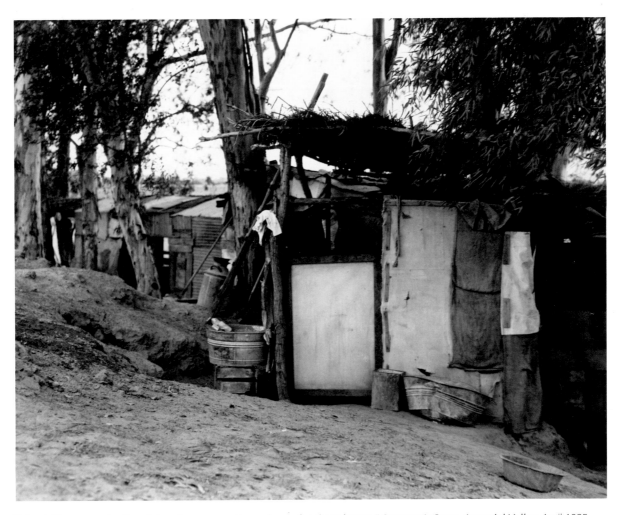

"I don't like you make the picture because we have shame for thees house," Squatter's Camp, Imperial Valley, April 1935

"People just can't make it back there, with drought, hailstorms, duststorms, insects. People exist here and they can't do that there. You can make it here if you sleep lots and eat little, but it's pretty tough, there are so many people. They chase them out of one camp because they say it isn't sanitary—there's no running water—so people live out here in the brush like a den o' dogs or pigs."

Squatters in the brush near Wasco, California, June 6, 1938

"I had begun to talk to the people I photographed. For some reason, I don't know why, the people in the city were silent people, and we never spoke to each other. But in the migrant camps, there were always talkers. This was very helpful to me, and I think it was helpful to them. It gave us a chance to meet on common ground..."

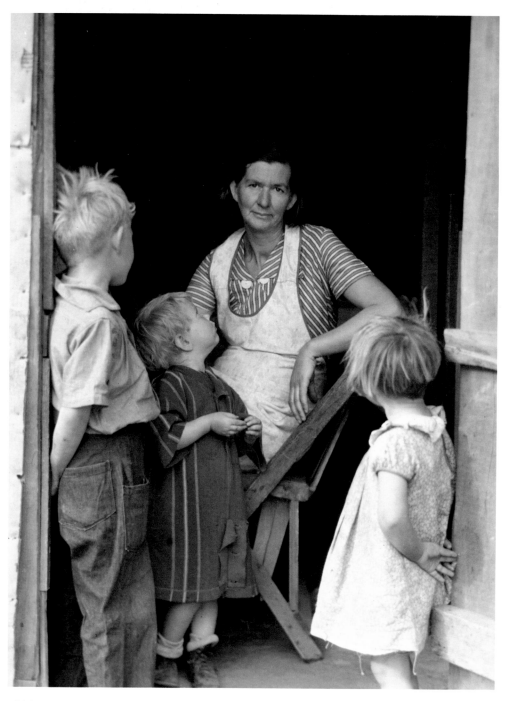

Oklahomans in Public Camp on relief, Coachella Valley, February 1935

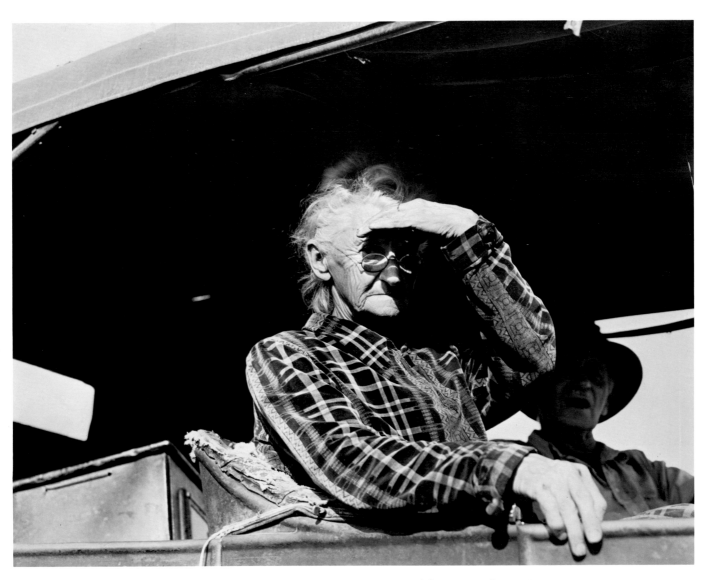

Eighty-year-old woman living in a squatter's camp on the outskirts of Bakersfield, California, November 1936

Grandmother of 22 children, from a
farm family in Oklahoma. "If you lose
your pluck, you lose the most there is
in you—all you've got to live with."

Monday night February 24 1936

Dear Mr. Stryker :- Have just finished loading and
unloading the films. It's late. I'm tired. Had a
good day today but I'm done up — and there are all
those notes and explanations, Essays on the social scene
in California IS what they should be — Still to be
done. There is still work to be done here in Bakersfield area
and I am expected in Los Angeles tomorrow night.

The rains are about over. Had to get out of the
San Luis Area well the job unfinished before the road washed
away. Will stop there again on the return trip. On some
of the film which I am mailing you I took long chances —
and they are probably failures. Tried to work in the pea camps
in heavy rain from the back of the station wagon. I doubt
that I got anything. Made other mistakes too, which will be
very apparent to you. There are some tripod slips and some
blanks. I make the most mistakes on subject matter that
I get excited about and enthusiastic. In other words, the worse
the work. the richer the material was.

Yours,
Lange

Bakersfield

Migrant agricultural worker's family. Seven hungry children. Mother, age thirty-two. Father is a native Californian. Destitute in pea pickers' camp, Nipomo, California, because of the failure of the early pea crop. These people had just sold their tent in order to buy food. Of the 2,500 people in this camp, most of them were destitute.

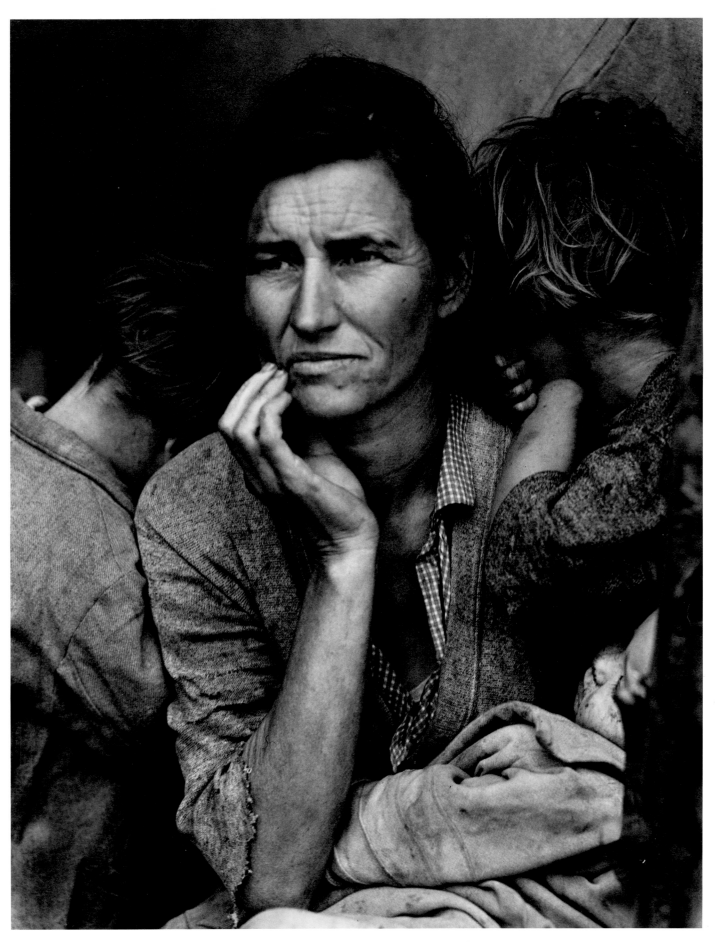

Migrant Mother, Nipomo, California, March 1936

Ruby from Tennessee, daughter of
a migrant worker living in American
camp near Sacramento, California.
Daughter in a family of six who
moved to California a little over a
year ago. Father was a coal miner in
Tennessee, but when the mines were
not working he received two days a
week relief work. "Thought we could
make it better out here." They have
worked in grapes, near Lodi, in wal-
nuts elsewhere, and on a wood job
above Marysville. From November to
March, they "tuk to the hills"—went
back to Tennessee—but came right
back to California. March is when the
cannery starts here, and they have
camped here since March.

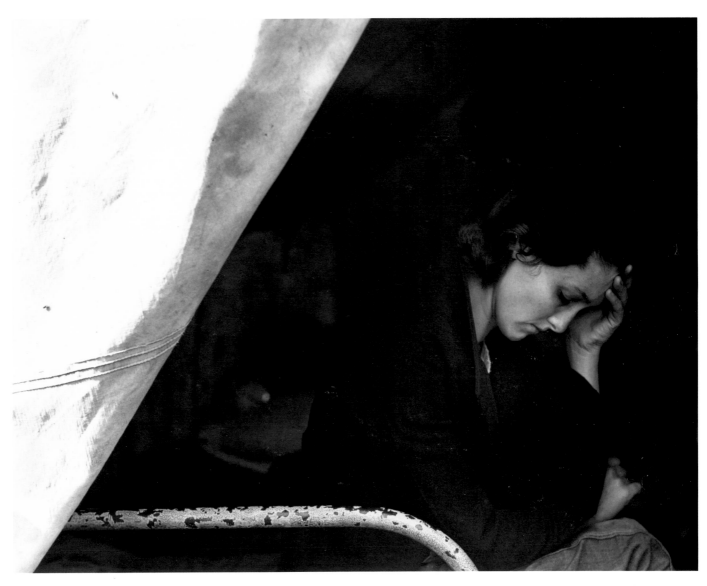

Refugee from Drought, Dust, Depression, near Sacramento, California, November 1936

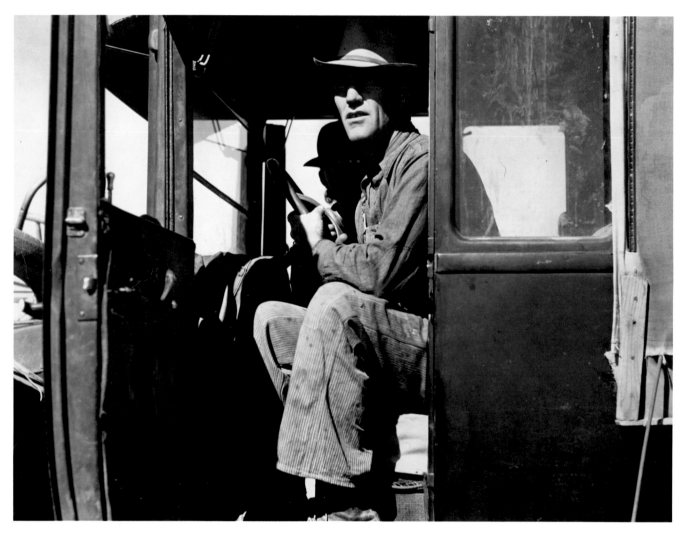

Texas Family looking for work in the carrot harvest, Coachella Valley, February 1937

Texas farmer parked on edge of carrot
field. In California for two weeks,
migrating after three years of crop
failure. Combined earnings, man and
wife tying carrots, $1.12 a day.

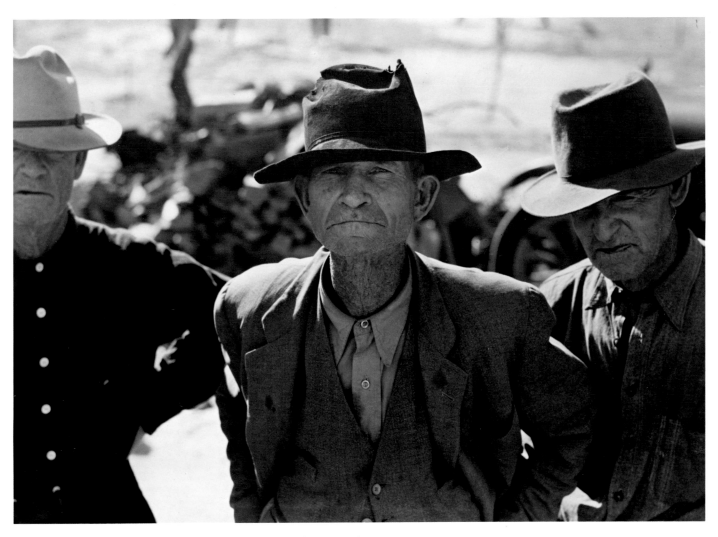

Ex-Tenant Farmer on relief grant in the Imperial Valley, California, March 1937

"Their roots were all torn out. The only background they had was a background of utter poverty. It's very hard to photograph a proud man against a background like that, because it doesn't show what he's proud about. I had to get my camera to register the things about those people that were more important than how poor they were—their pride, their strength, their spirit."

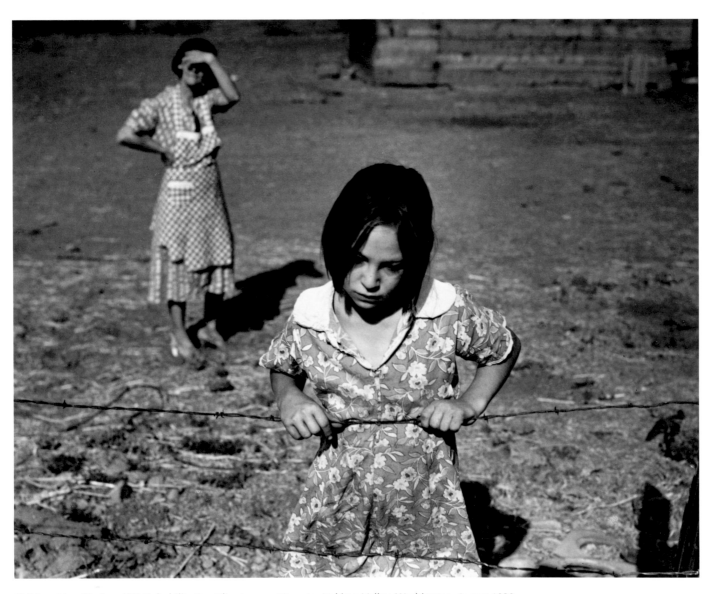

Child and her Mother, FSA Rehabilitation Clients, near Wapato, Yakima Valley, Washington, August 1939

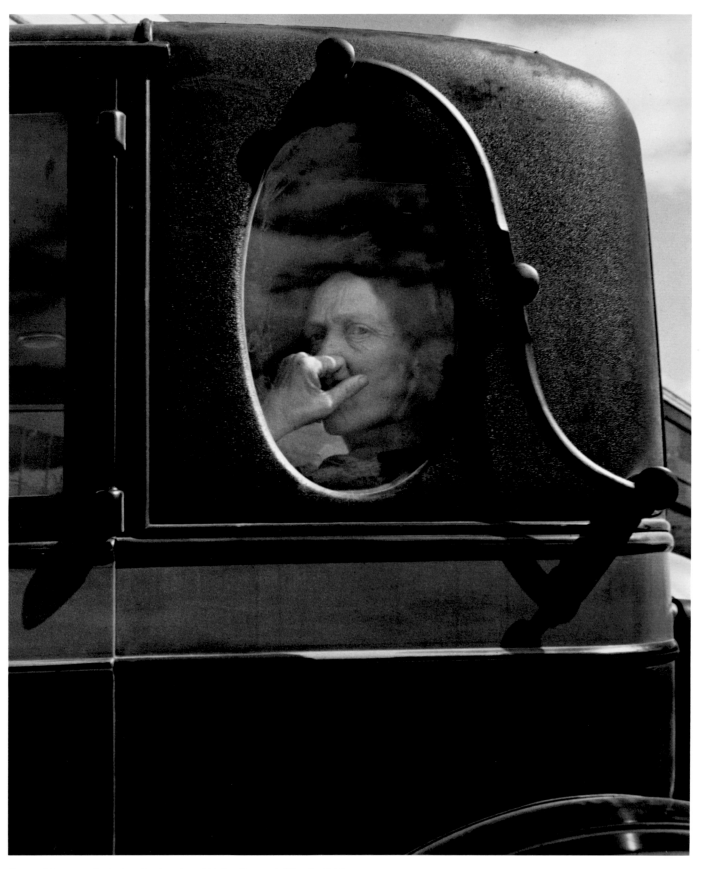

Funeral Cortege, End of an Era in a Small Valley Town, California, 1938

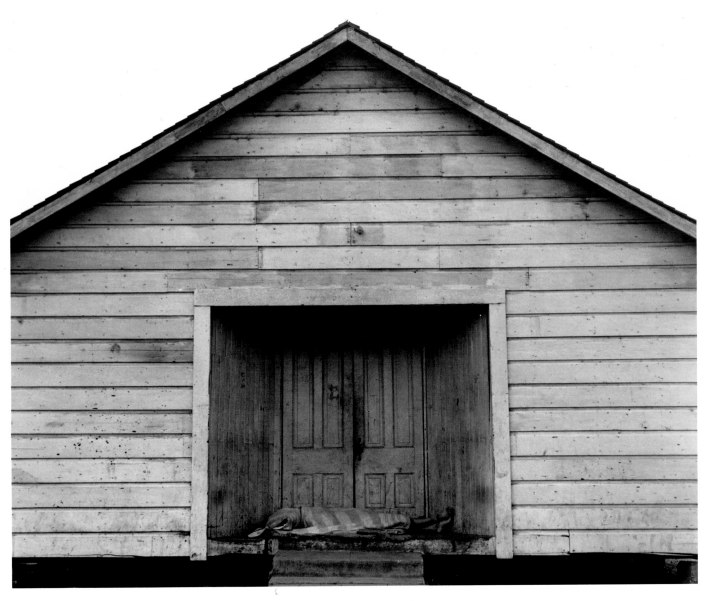

Death in the Doorway, Grayson, San Joaquin Valley, California, 1938

"*Grayson was a migratory agricultural laborers'shack-town. It was during the season of the pea harvest. Late afternoon about six o'clock. Boys were playing base-ball in the road that passes this building, which was used as a church. Otherwise, this corpse, lying at the church door, was alone, unattended, and unexplained.*"

"We want help. We need a lot of help. But we don't want to be looked down on, and called a new bunch of names, to replace the old ones. I'd rather be some-one's son-of-a-bitch, than someone's beaten down goner, about to disappear from the face of the earth! I'd rather be neither; I'd rather be myself, only better off. How do you get better off? And when you are better off, how do you get to be 'yourself,' and no copy-cat of everyone else?"

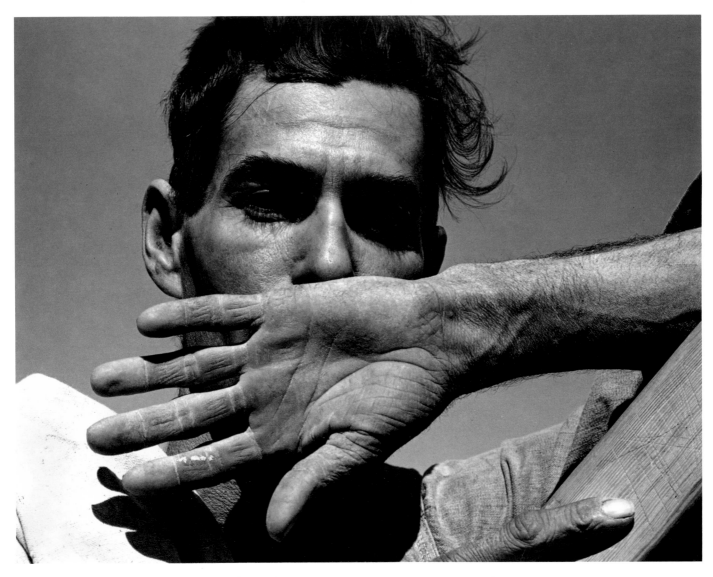

Migratory Cotton Picker, Eloy, Arizona, November 1940

Resting at cotton wagon before
returning to work in the field. He has
been picking cotton all day. A good
picker earns about two dollars a day
working, at this time of year, about
ten hours. This is an area of rapidly
expanding commercial cotton culture.

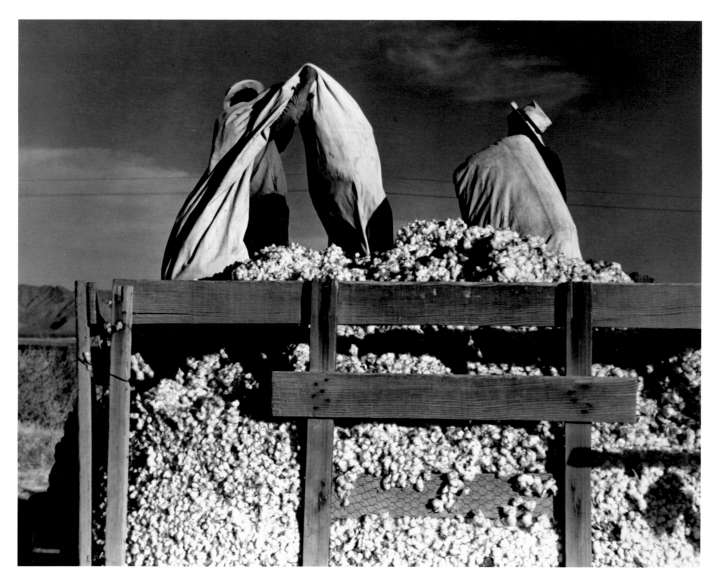

Cotton Wagon, Eloy, Arizona, November 1940

Late afternoon—migratory cotton
pickers dump their sacks into the
field wagons, seventy-five cents per
hundred pounds.

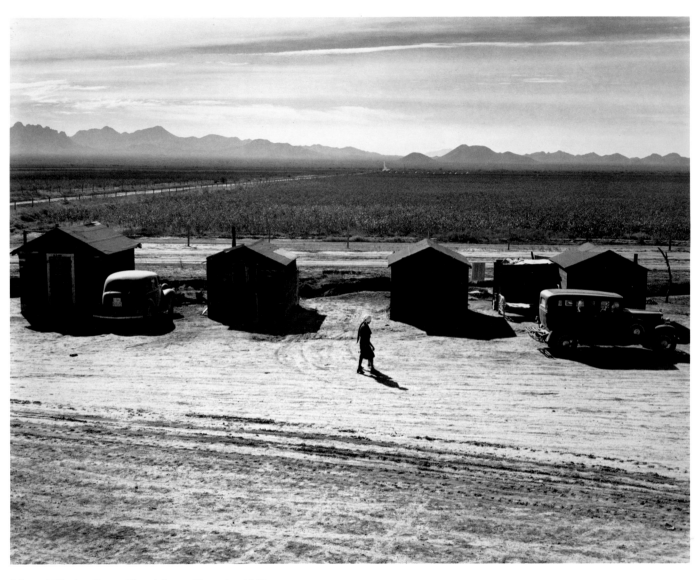

Migrant Worker Camp, Eloy, Arizona, November 1940

This camp has eight lumber shacks,
twelve tents without floors, two toilets,
two water faucets. Note cotton fields
across the road and another cotton
camp in the distance.

"These are women of the American soil. They are a hardy stock. They are of the roots of our country. They inhabit our plains, our prairies, our deserts, our mountains, our valleys, and our country towns. They are not our well-advertised women of beauty and fashion, nor are they a part of the well-advertised American style of living. These women represent a different mode of life. They are of themselves a very great American style. They live with courage and purpose, a part of our tradition."

Arkansas mother come to California for a new start, with husband and eleven children.

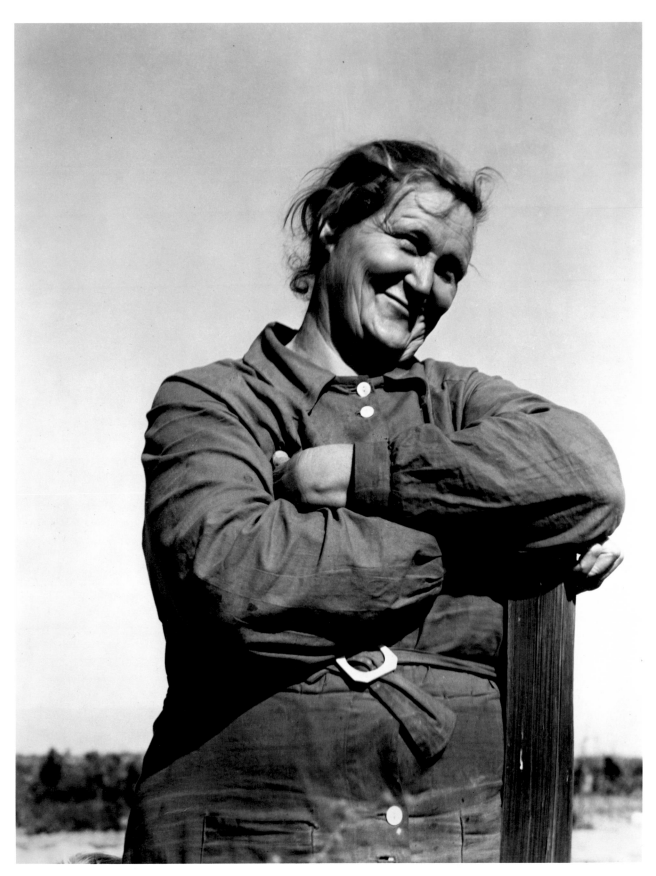

Rural Rehabilitation Client, Tulare County, California, November 1938

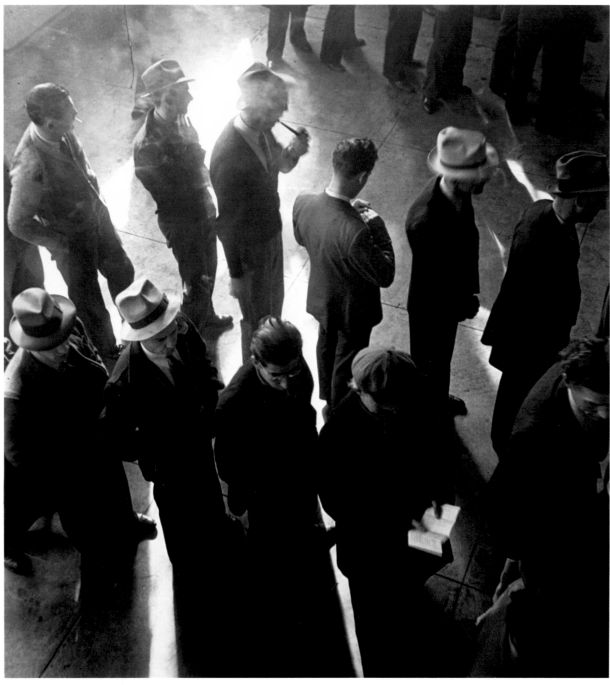

San Francisco Social Security Office, January 1938

Unemployment Benefits aid begins. Line of men inside a division office of the State Unemployment Service office at San Francisco, California, waiting to register for benefits on one of the first days the office was open. They will receive from six dollars to fifteen dollars per week for up to sixteen weeks. Coincidental with the announcement that the Federal Unemployment Census showed close to 10 million persons out of work, twenty-two states began paying unemployment compensation.

San Francisco, January 1939

After 44 years of Republican admin-
stration, California gets a Democratic
administration. The California "New
Deal" faces the same opposition as
the national "New Deal."

"Everything is propaganda for what you believe in...
I don't see that it could be otherwise. The harder and
more deeply you believe in anything, the more in a
sense you're a propagandist. Conviction, propaganda,
faith. I don't know, I never have been able to come to
the conclusion that that's a bad word."

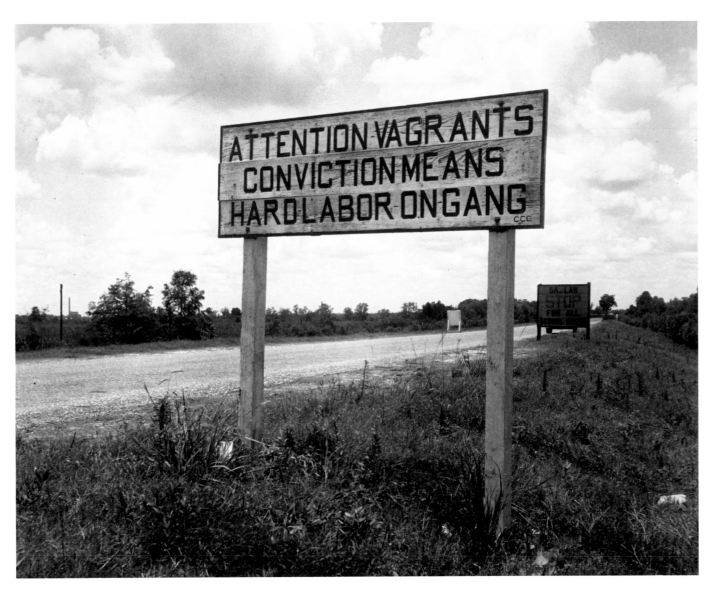

Entering the State of Georgia, 1936

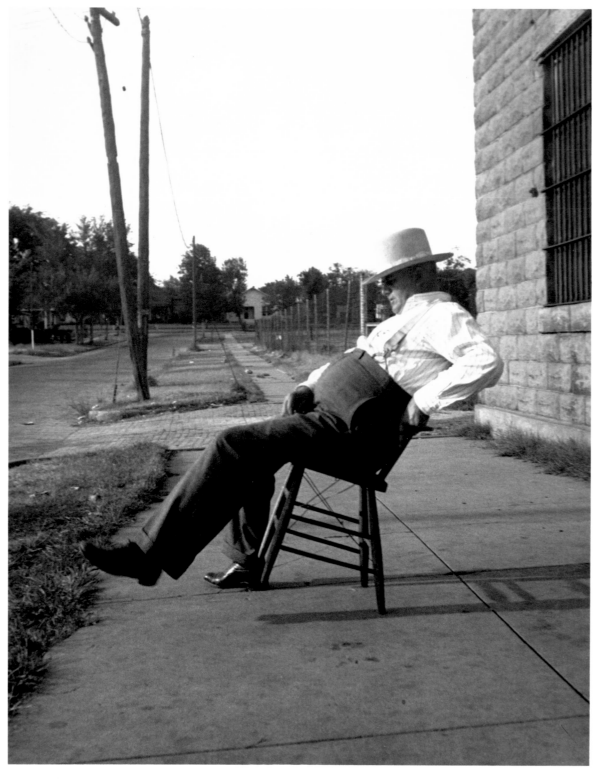

The Sheriff of McAlester, Oklahoma, sitting in front of the jail, August 1936

He has been sheriff for thirty years.

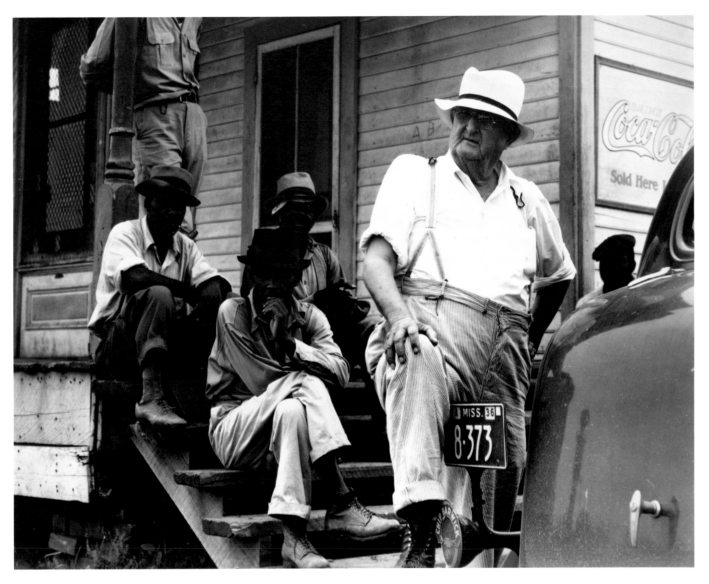

Plantation Overseer, Mississippi Delta, near Clarksdale, Mississippi, July 1936

"*Earlier, I'd gotten at people through the ways they'd been torn loose, but now [in the South] I had to get at them through the ways they were bound up...*"

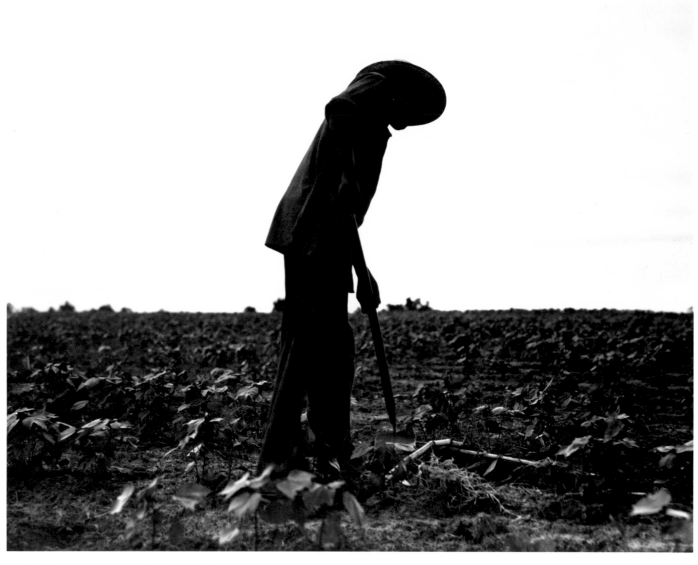

Hoeing Cotton, near Yazoo City, Mississippi, June 1937

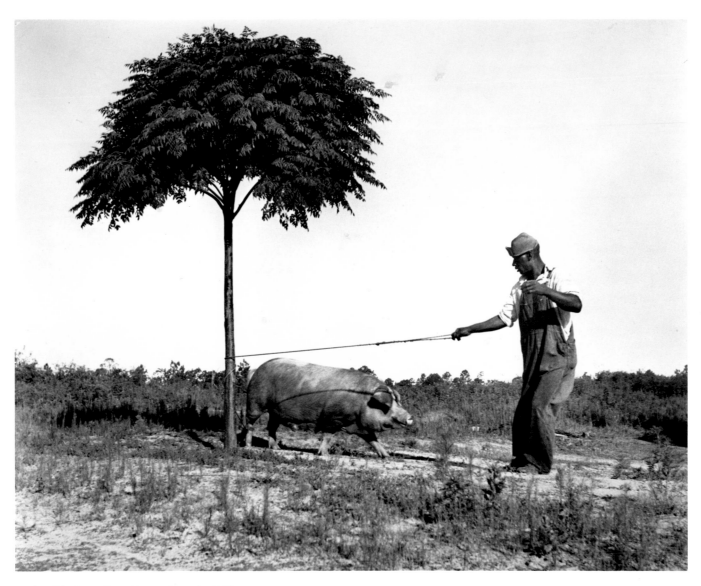

By the Chinaberry Tree, Tipton, Georgia, 1938

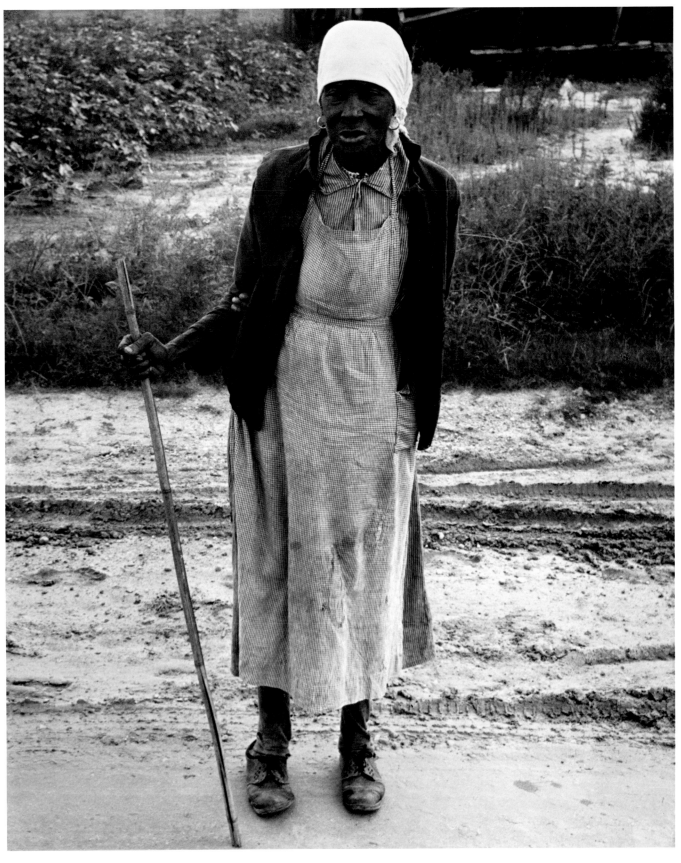

Ex-Slave with a Long Memory, Alabama, 1937

"My father was a Confederate soldier. He gave his age a year older than it was to get into the army. After the war he bought 280 acres from the railroad and cleared it. We never had a mortgage on it. In 1920 that land was sold, and the money divided. Now none of my children own their land.

"It's all done gone, but it raised my family.

"I've done my duty—I feel like I have. I've raised twelve children, six dead and six alive—and two orphans.

"Then all owned their farms. The land was good and there was free range. We made all we ate and wore. We had a loom and a wheel. The old settlers had the cream. Now this hill land has washed, and we don't get anything for what we sell. We had two teams when this depression hit us. We sold one, we had to get by, and we sold four cows.

"In 1935 we got only fifty and sixty cents a hundred pounds for picking and in 1936, only sixty and seventy-five cents, and we hoe for seventy-five cents a day.

"Then the government reduced the acreage, and where there was enough for two families, now there's just one. Some of the landowners would rather work the cotton land themselves and get all the government money. So they cut down to what they can work, and the farming people, they go to town on relief. The sharecroppers are just cut out.

"Then the Lord took a hand in it, and by the time He'd taken a swipe, there was drought and army worm. I don't know for sure whose work it was, the Lord's or the devil's, but in three days everything wilted.

"Folks from this part has left for California the last year or so. My two grandsons went to California to hunt work. It was a case of 'haf to.' When you see 'em out there, tell 'em you were talking to old lady Graham, in Arkansas."

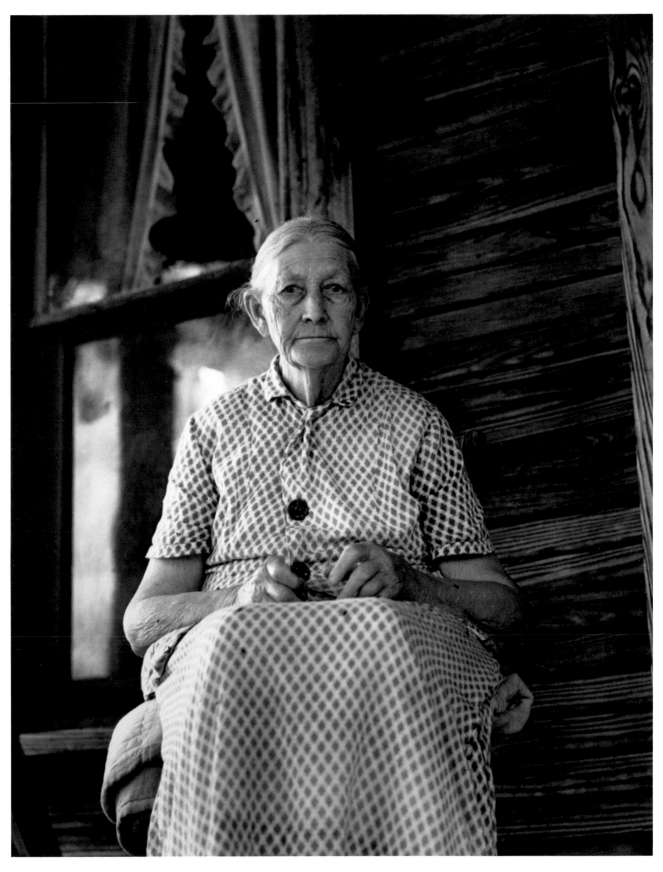

Ma Graham, an "Arkansas Hoosier," born in 1855, Conway, Arkansas, June 1938

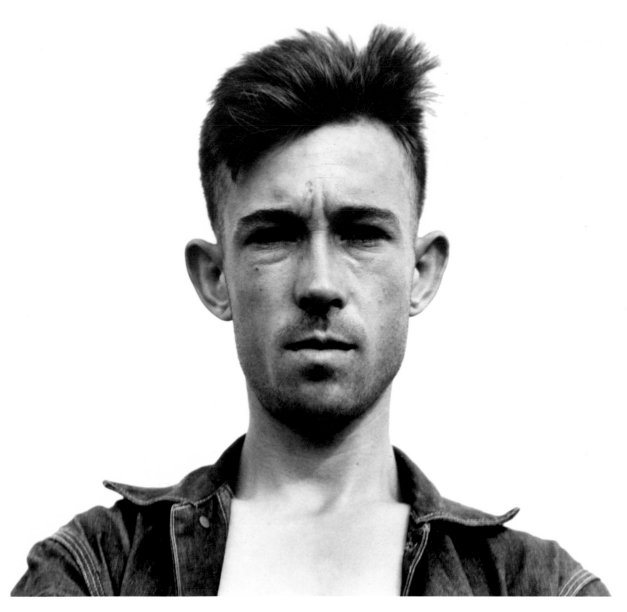

Sharecropper who receives $5 a month "furnish" from the landowner, Macon County, Georgia, July 1937

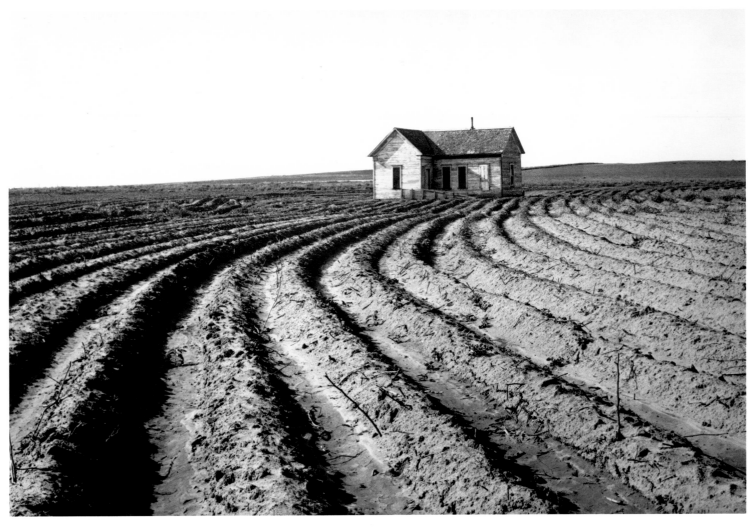

Tractored Out, Childress County, Texas, June 1938

Tractors replace not only mules, but
people. They cultivate to the very
door of the houses of those whom
they replace.

All displaced tenant farmers.
The oldest 33.

All native Americans, none able to vote because of Texas poll tax. All on WPA. They support an average of four persons each on $22.80 a month.

"Where we gonna go?"
"How we gonna get there?"
"What we gonna do?"
"Who we gonna fight?"
"If we fight, what we gotta whip?"

North Texas, Sunday morning, June 1937

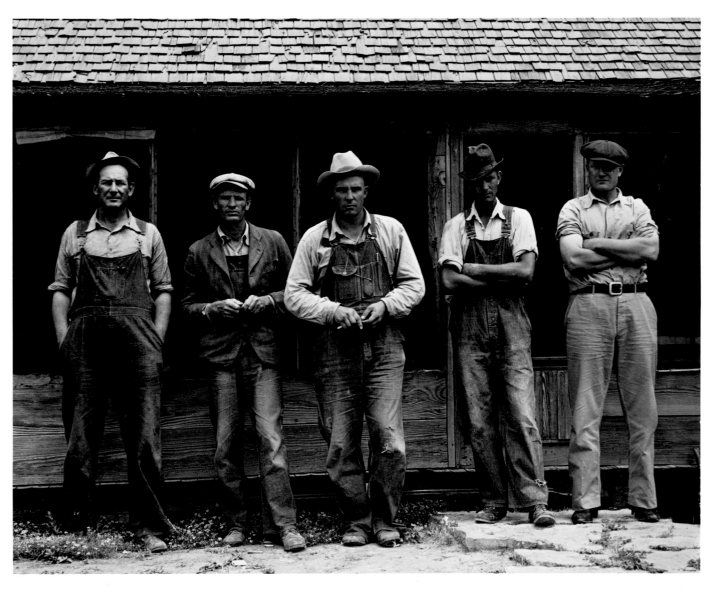

Former Texas Tenant Farmers displaced from their land by tractor farming, Hardeman County, Texas, 1937

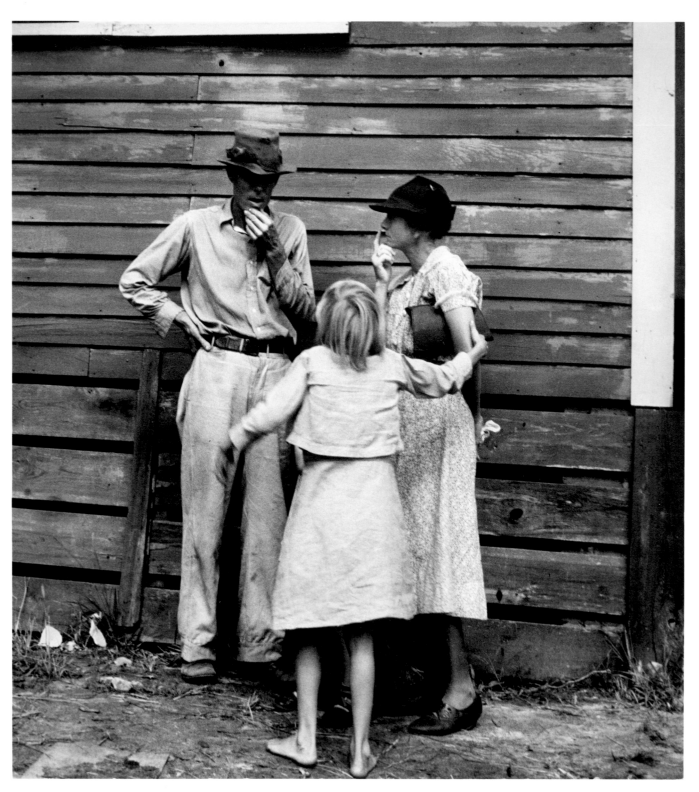

Farm Family which has just sold its year's crop at tobacco auction, Douglas, Georgia, July 1938

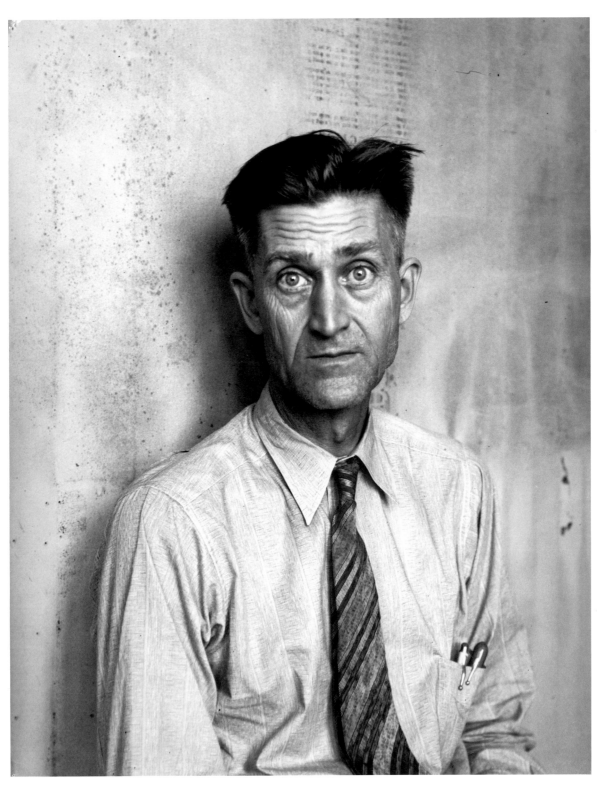

J.R. Butler, President of the Southern Tenant Farmers' Union, Memphis, Tennessee, 1938

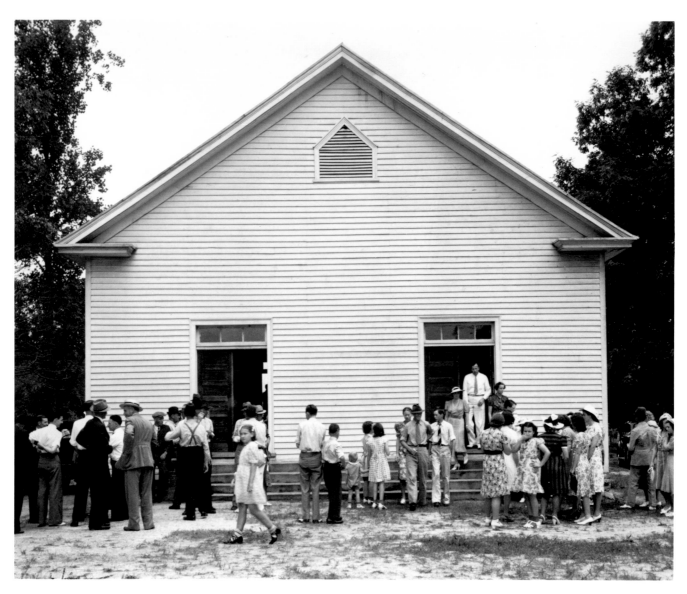

The Congregation Gathers after the service to talk, Wheeley's Church, near Gordonton, Person County, North Carolina, July 1939

The church is primitive Baptist— "don't know whether you ever heard of that kind or not"—and is "over a hundred years old" but no one seemed to know exactly...Preaching once a month and the church is crowded...No pictures taken inside the church because of hesitation of church members. The people are substantial, well-fed looking, the women in clean prints mostly ready made, the men in clean shirts and trousers, some overalls. Good-looking children. Many addressed each other as cousin or aunt, etc. Very gay and folksy—evidently having a good time together. Cars new or relatively so and not all Fords. A group of solid country people who live generously and well.

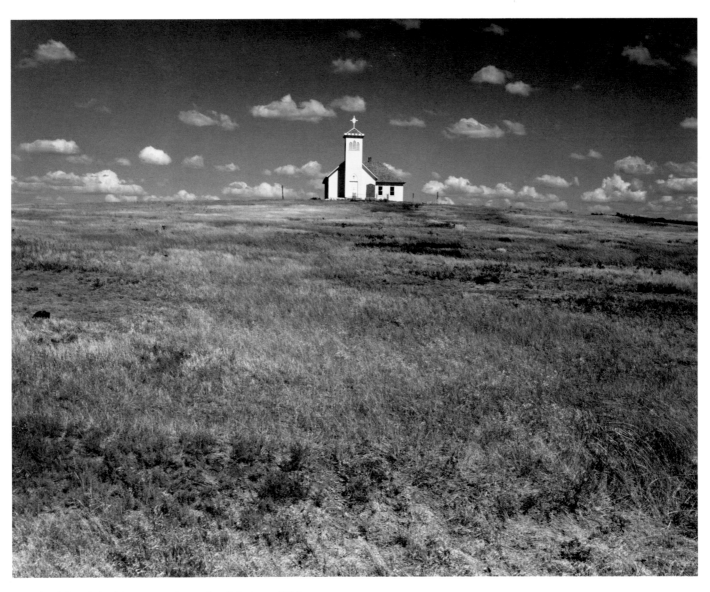

Church of the High Plains, near Winner, South Dakota, 1938

"What I photographed was the procedure, the process
of processing. I photographed the normal life insofar as
I could, in three parts of California... I photographed,
for instance, the Japanese quarter of San Francisco,
the businesses as they were operating, and the people
as they were going to their YWCAs and YMCAs
and churches and in their Nisei headquarters, all the
baffled, bewildered people...

"Everything that was possible that they could do them-
selves, they did—asked the minimum, took huge
sacrifices, made practically no demands. This was very
unusual, almost unbelievable, and this I photographed,
the long lines on the street waiting...for the inocula-
tions, down Post Street and around the corner...
Then I photographed them on the buses, on the trains,
and I photographed their arrival in the assembly
centers... And then they were moved again, into the
interior, and I photographed only one of the interior
centers, Manzanar, in Owens Valley."

Two days before the Army evacuated
all persons of Japanese ancestry from
the Pacific Coast.

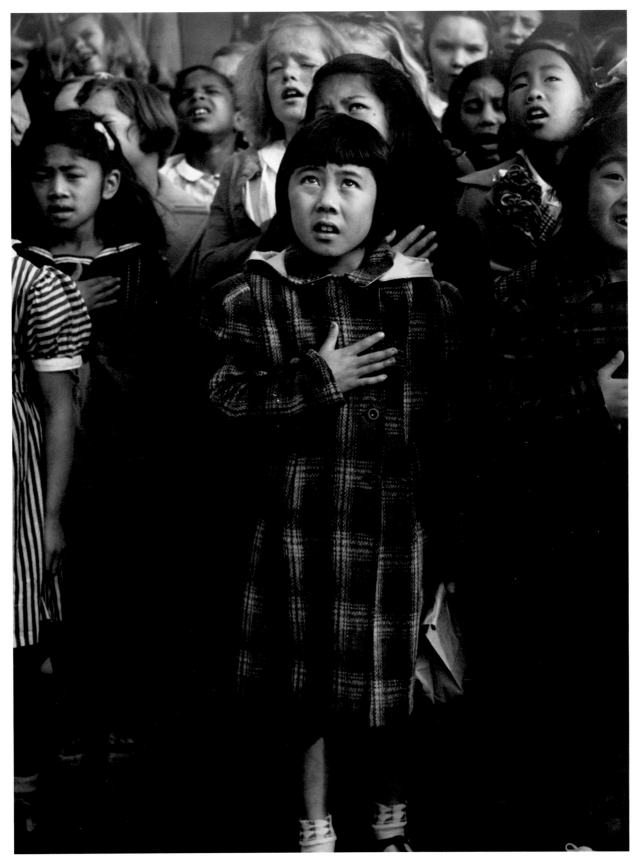

Pledge of Allegiance at Rafael Weill Elementary School, San Francisco, April 1942

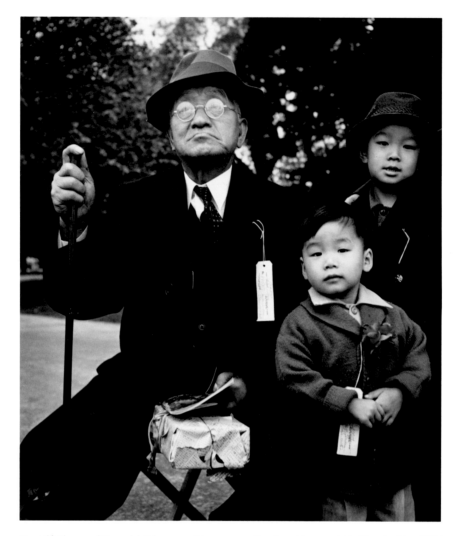

Grandfather and Grandchildren awaiting evacuation bus, Hayward, California, May 1942

"*These people came, with all their luggage and their best clothes and their children dressed as though they were going to an important event. New clothes, that was characteristic...*

"*The whole thing, the feelings and tempers and people's attitudes were very complex and very heated at that time. People certainly lost their heads... What was, of course, horrifying, was to do this thing completely on the basis of what blood may be coursing through a person's veins, nothing else. Nothing to do with your affiliations or friendships or associations. Just blood...*"

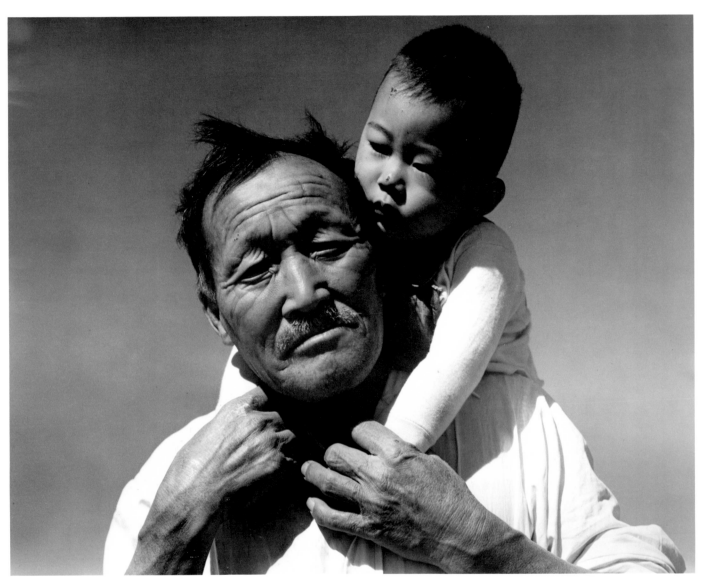

Grandfather and Grandson, Japanese Relocation Camp, Manzanar, California, 1942

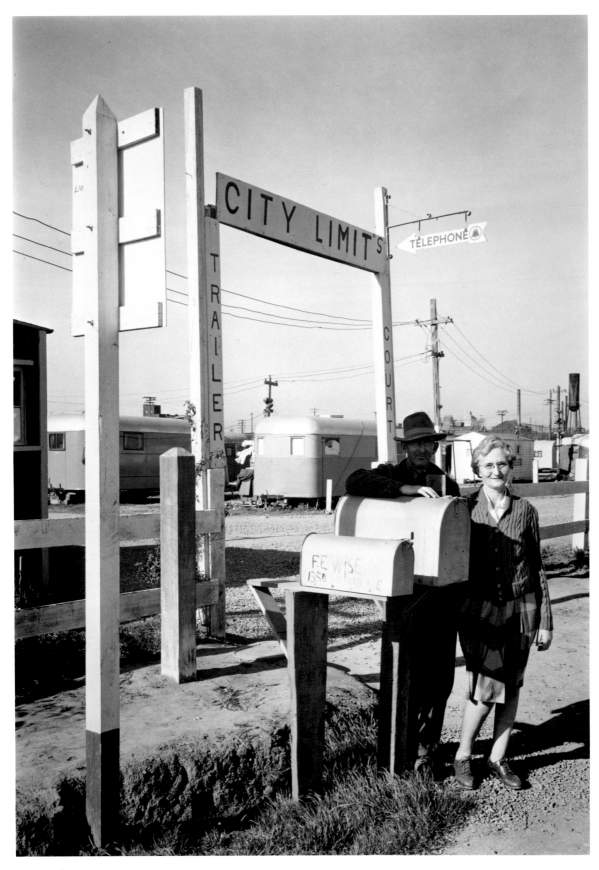

Trailer Court, near Richmond, California, ca. 1943-44

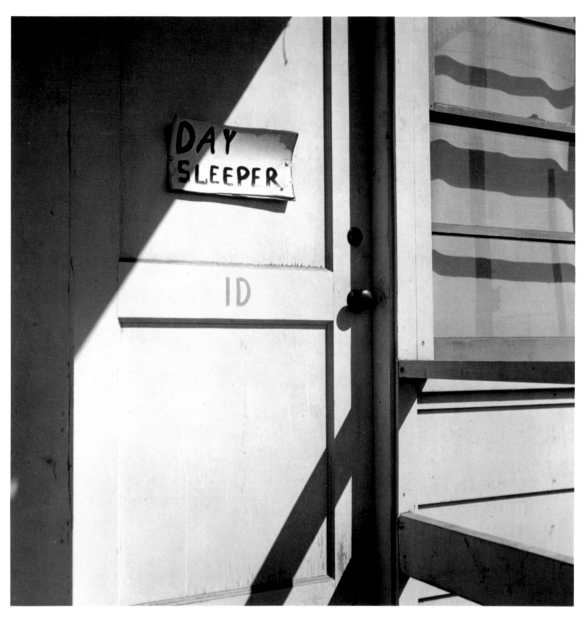

Day Sleeper, 1D, Richmond, California, ca. 1942-44

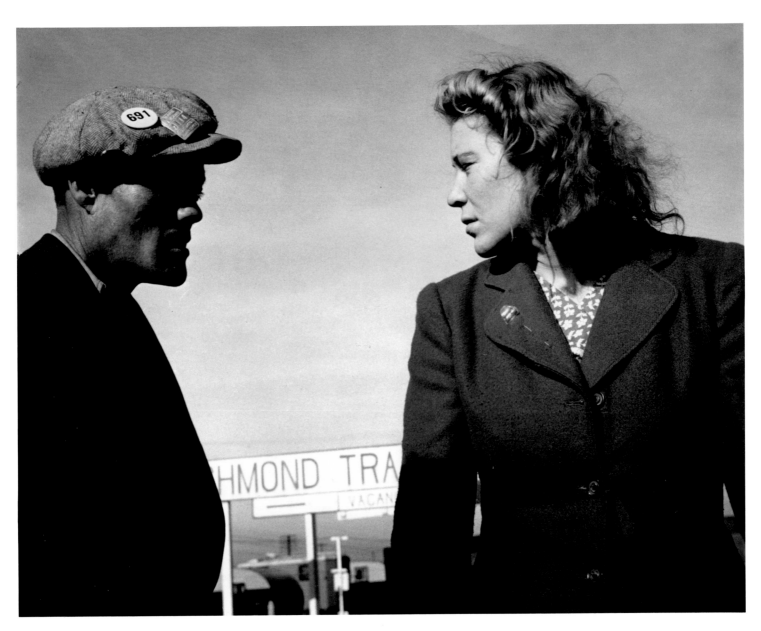

Argument in a Trailer Court, Richmond, California, 1944

Young war workers, transplanted and in
a strange town, angered and miserable.

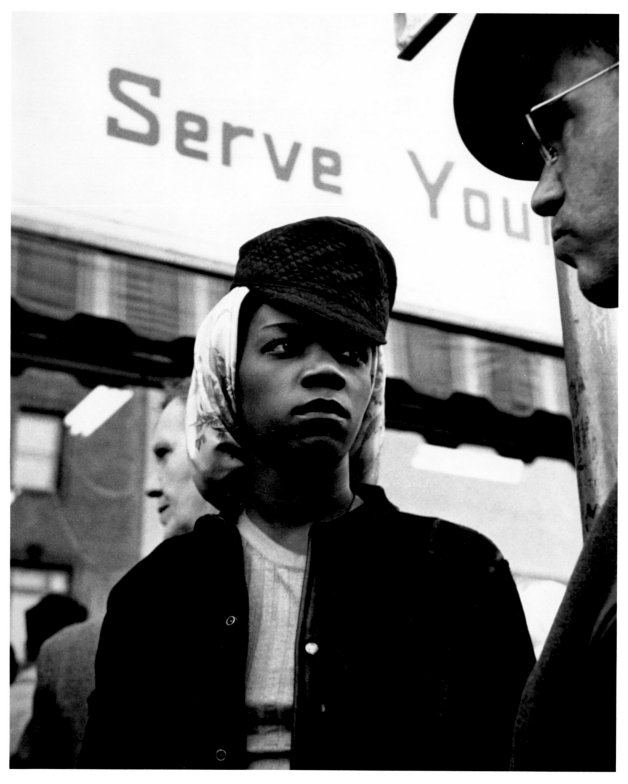

Street Encounter, Richmond, California, ca. 1943

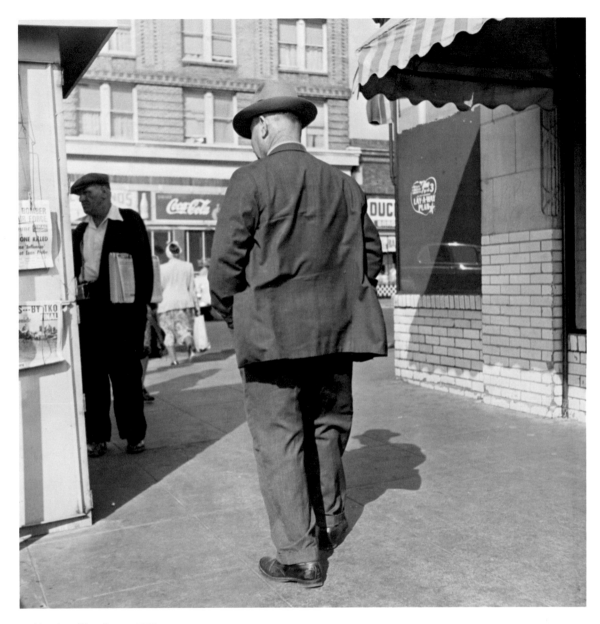

Oakland, California, ca. 1951

"*I wouldn't have any idea who he is—or why he stands
there. It was the way that suit of clothes fit his figure
(a powerful man in tweed) and the detailed feel of him.
Probably a foreign-born, not at home.*"

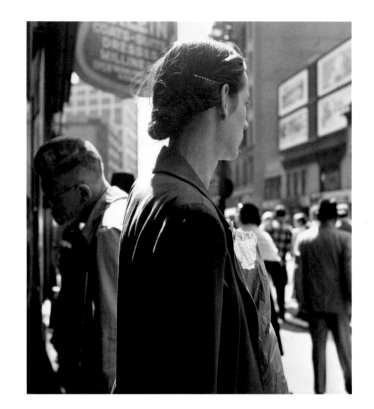

"I find that it has become instinctive, habitual, necessary, to group photographs. I used to think in terms of single photographs, the Bulls-eye technique. No more."

New York City, 1952

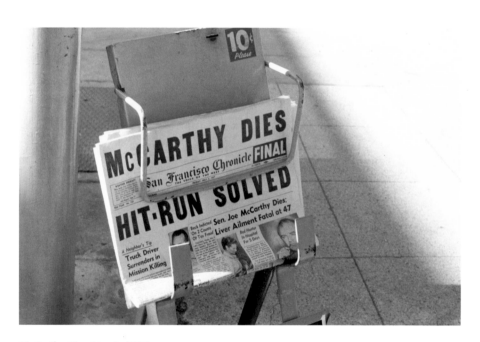

McCarthy Dies, May 5, 1957

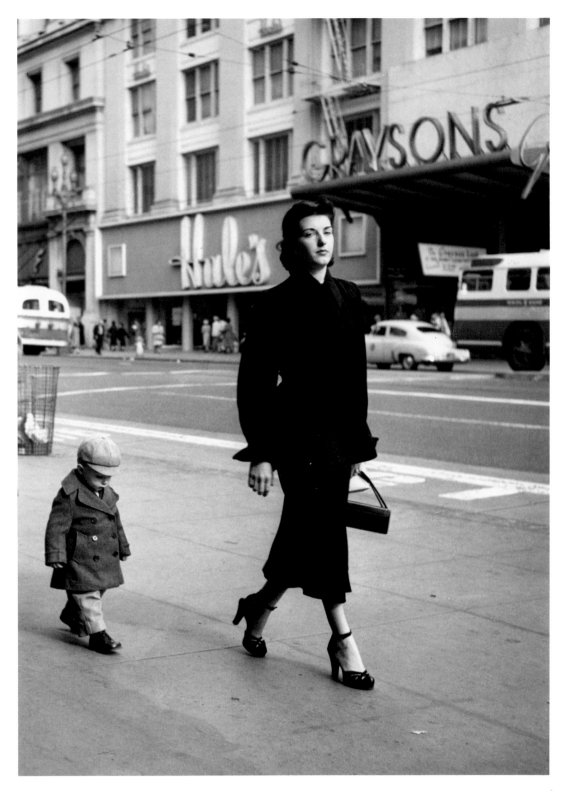

Consumer Relations, San Francisco, 1952

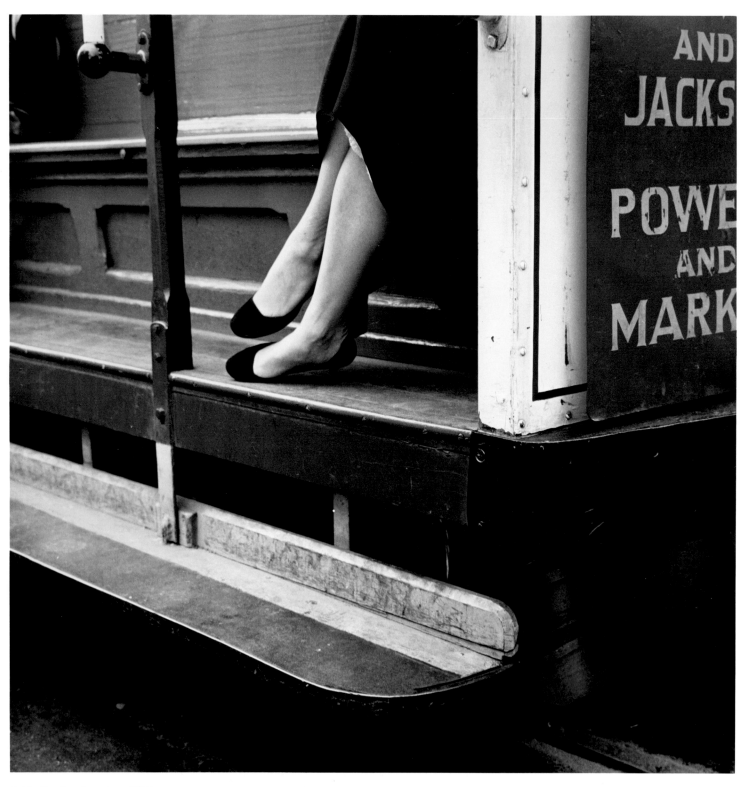

Cable Car, San Francisco, 1956

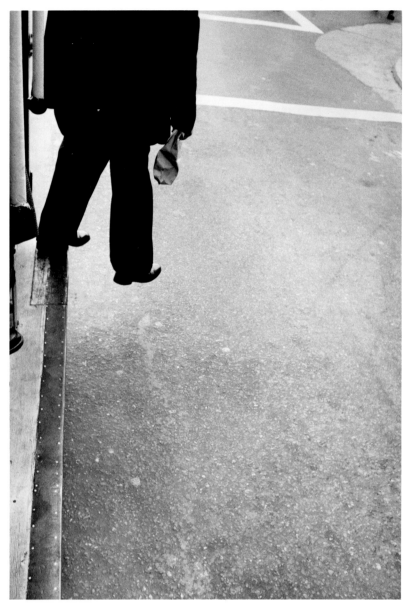

Man Stepping Off Cable Car, San Francisco, 1956

"Documentary photography records the social scene of our time. It mirrors the present and documents for the future. Its focus is man in his relation to mankind. It records his customs at work, at war, at play, or his round of activities through twenty-four hours of the day, the cycle of seasons, or the span of a life. It portrays his institutions—family, church, government, political organizations, social clubs, labor unions. It shows not merely their facades, but seeks to reveal the manner in which they function, absorb the life, hold the loyalty, and influence the behavior of human beings."

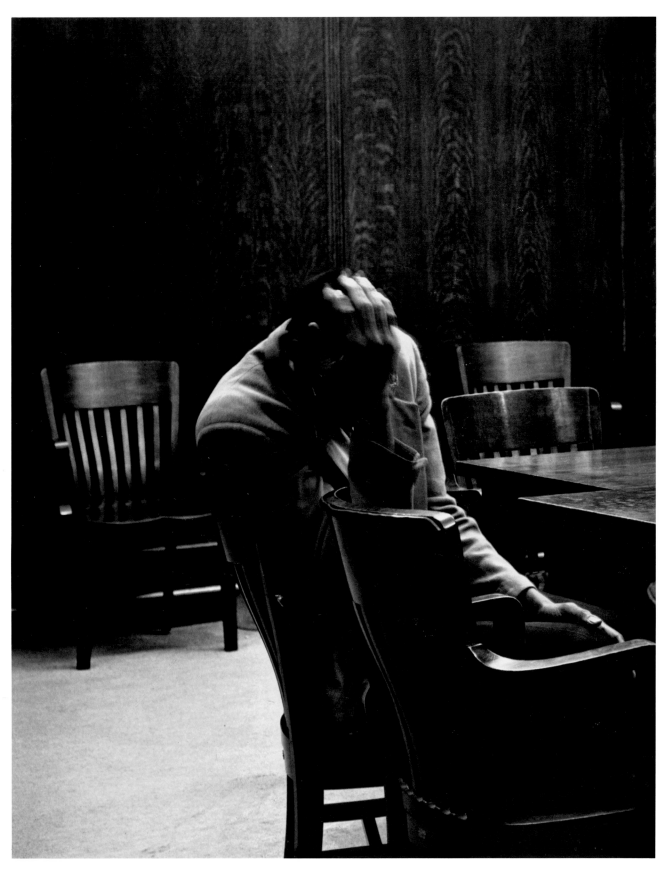

The Defendant, Alameda County Courthouse, California, 1957

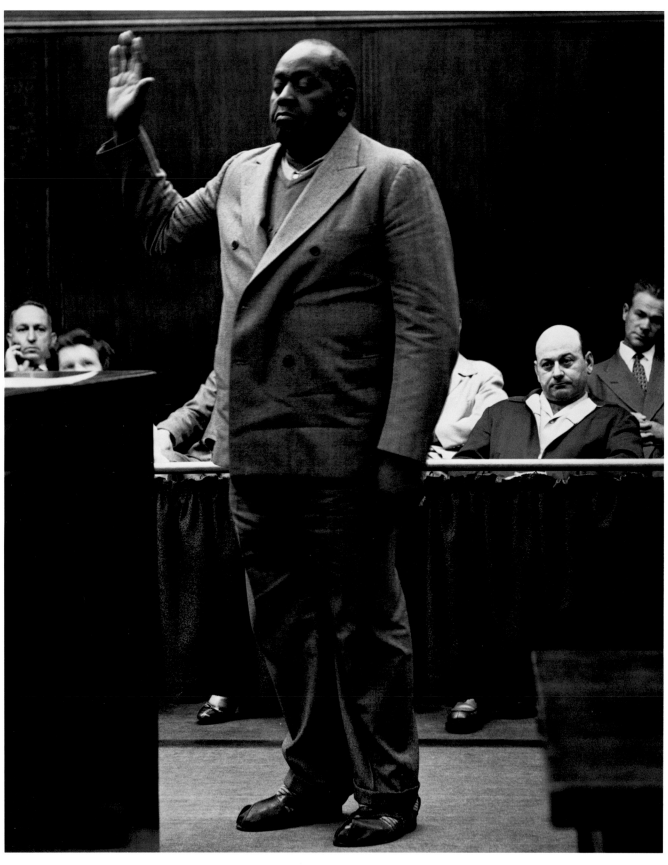

The Witness, 1957

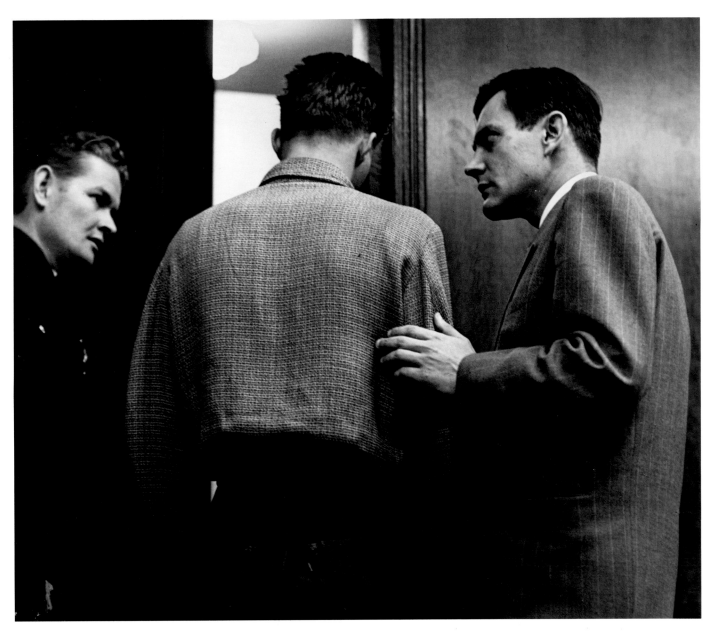

Leaving Courtroom after Conviction, 1957

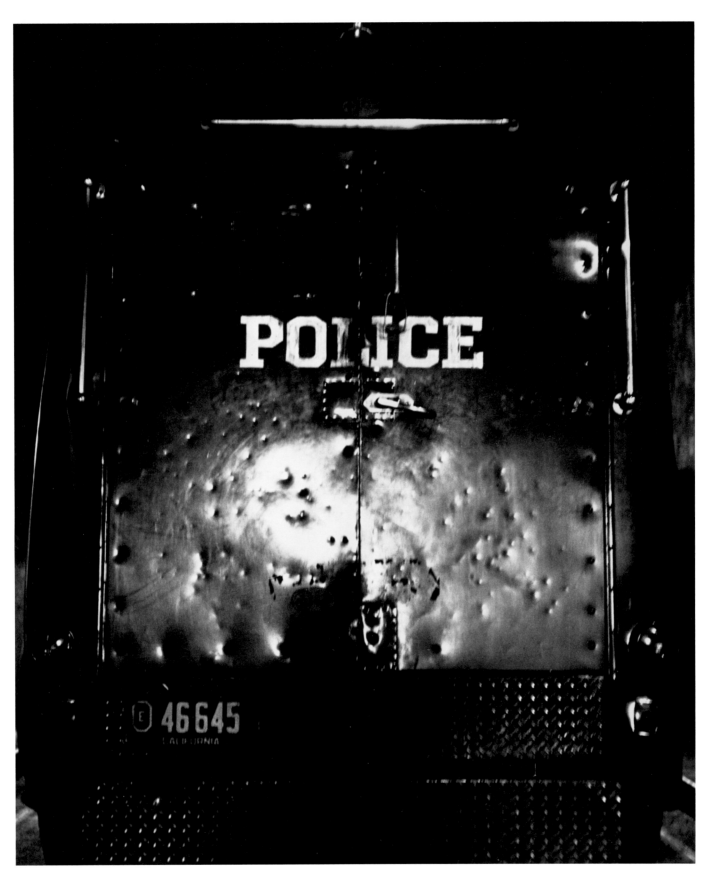

Black Maria, Oakland, 1957

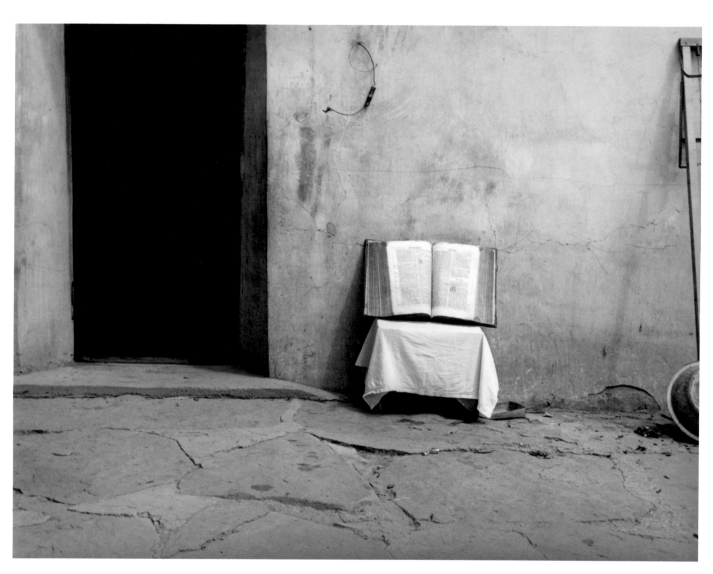

Hutterite Bible, west of Vermillion, South Dakota, 1941

"[The photographer of today] is often left with the feeling that there is nowhere to go. He is lost; he is confused; he is bewildered. Accustomed to discovery, now suddenly he is obliged to interpret... Thus the spectacular is cherished above the meaningful, the frenzied above the quiet, the unique above the potent. The familiar is made strange, the unfamiliar grotesque...

"In this unwillingness to accept a familiar world photography puts invention to a destructive work. That the familiar world is often unsatisfactory cannot be denied, but it is not, for all that, one we need abandon. Awkward though it may be, ours is a world that still confers upon the artist an energy and sometimes even a comfort... Bad as it is, the world is potentially full of good photographs. But to be good, photographs have to be full of the world...

"What is familiar to one of us may very likely be familiar to another. Sweat in the eyes, sun on the back, cold in the heart—these things we all know. More important, we all know something of what they mean. Hard work, warm weather, pain, we all have enough in common to make most of our worlds companion to each other. We eating, we sleeping, we mourning and rejoicing, we hating, we loving—it is the same with these. These we know; so knowing, these we see; and it is in these that a great photograph speaks, not of eating and sleeping, but of ourselves. Whether of a board fence, an eggshell, a mountain peak or a broken sharecropper, the great photograph first asks, then answers, two questions. "Is that my world? What, if not, has that world to do with mine?..."

"Among the familiar, [the photographer's] behavior is that of the intimate rather than of the stranger. Rather than acknowledge, he embraces; rather than perform, he responds. Moving in a world so much composed of himself, he cannot help but express himself. Every image he sees, every photograph he takes, becomes in a sense a self-portrait...

"These, then, are the issues: whether we, as photographers, can make of our machine an instrument of human creation, whether we, as artists, can make of our world a place for creation."

Friend and neighbor, who makes "the world's best apple pie," and knows everything going on for miles around.

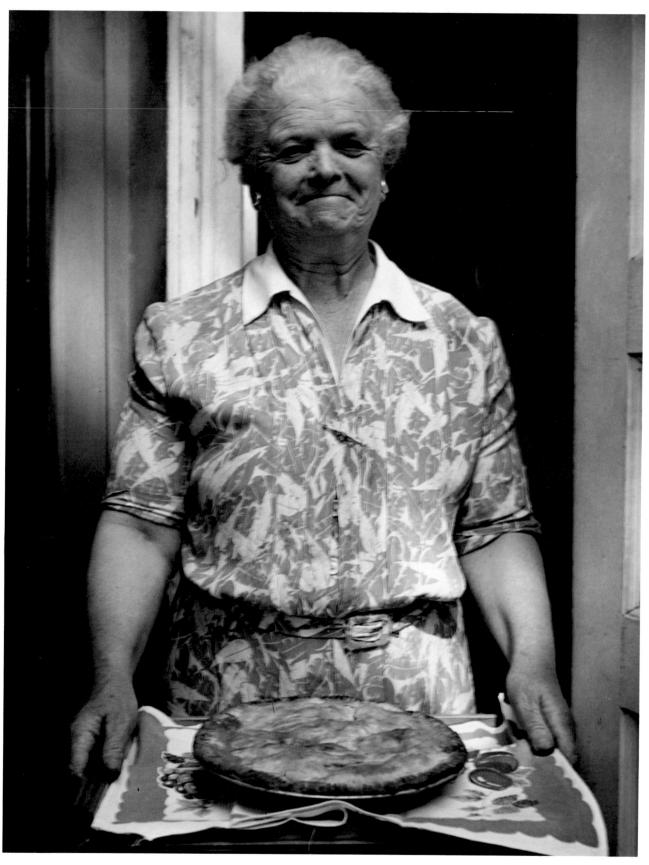

Lydia Wall, 1944

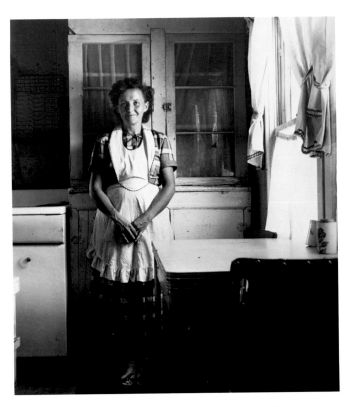

She lives in a Mormon hamlet strung along a small river, five miles inland from the highway. "If you run out of money here in Gunlock, you can go and pick yourself something out of the garden."

Young Mother, Gunlock, Washington County, Utah, 1953

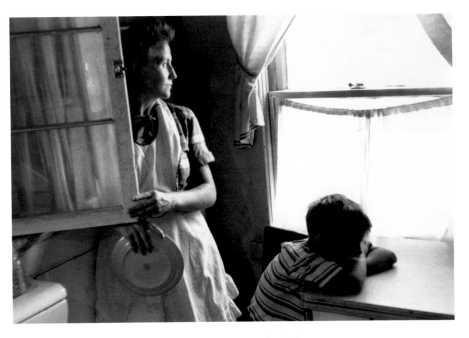

Mother and Child, Gunlock, Washington County, Utah, 1953

Gravestone, St. George, Utah, 1953

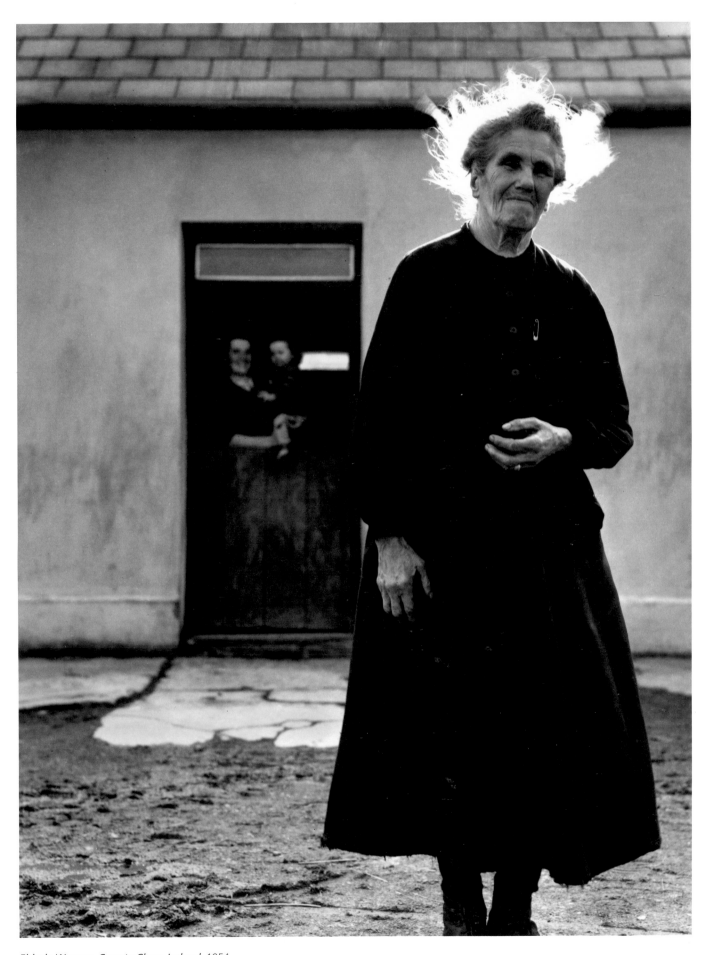

Elderly Woman, County Clare, Ireland, 1954

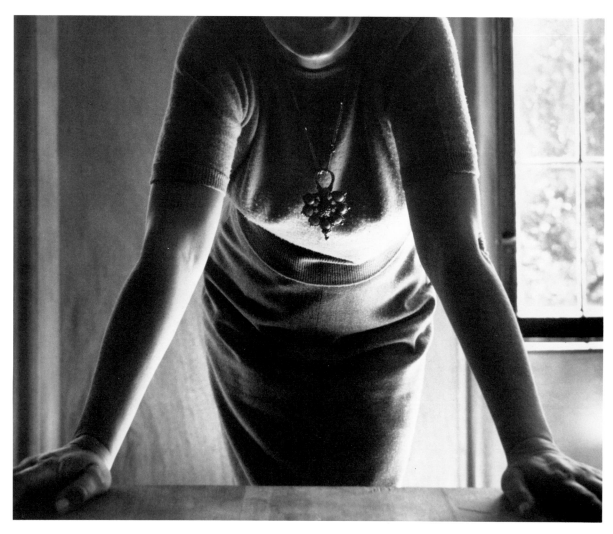

Berkeley, California, 1959

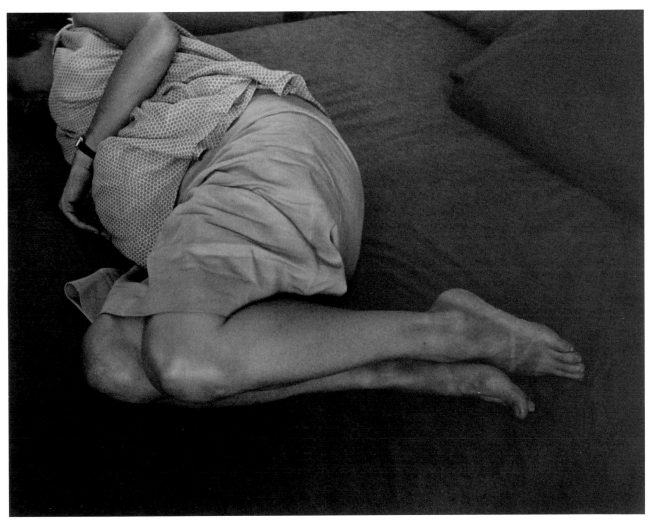

Winter, California, 1955

"In the past, events have always played a major role
in the work I've done. First there was the depression,
then the dustbowl, then the war. All of these were big,
harsh, powerful things, and it was related to them
that, as a rule, I tried to photograph people. Now,
however, I'm trying to get at something else. Instead
of photographing men in relation to events, today
I'm trying to photograph men in relation to men, to
probe the exchanges and communications between
people, to discover what they mean to each other
and to themselves. Usually, too, I'm trying to do this
in the most ordinary, familiar, usual kind of way.
By this I mean the relationships of a gardner to the
planting season, or of a young father to his first-born
son. Sometimes these relationships can be comic,
sometimes moving. But almost all of them are very
subdued and subtle, things you have to look very hard
to see, because they have been taken for granted not
only by our eyes but, often, by our hearts as well."

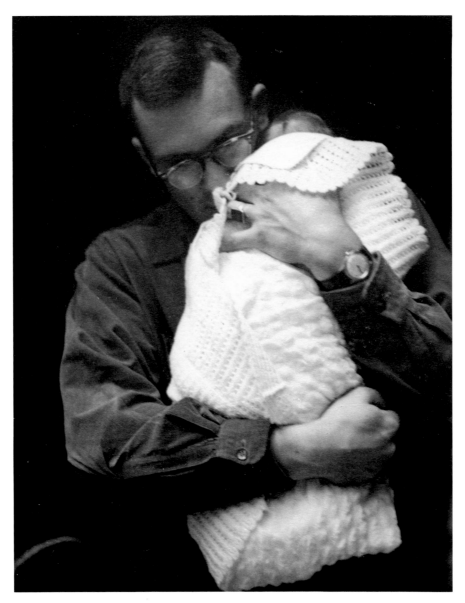

Third Born, 1958

"I'm always pushing in many directions at once, always trying to overreach myself. It keeps me constantly restless, and probing and fractured.

"However, that way of working engenders a very good kind of fatigue, because it keeps you alive. You may be exhausted by the complexities of your existence, but there is no retreat in it. You are right out on the thin edge all the time, where you are unprotected and defenseless."

"It's a very difficult thing to be exposed to the new and strange worlds that you know nothing about, and find your way... Being out of your depth is a very uncomfortable thing. In travel, for instance, you force yourself onto strange streets, among strangers. It may be very hot. It may be painfully cold. It may be sandy and windy and you say, 'What am I doing here? What drives me to do this hard thing?' But at the moment when you're thoroughly involved, when you're doing it, it's the greatest real satisfaction."

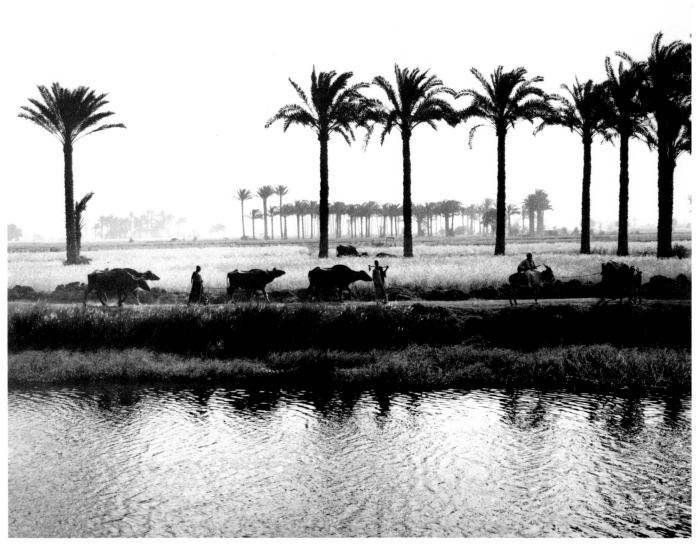

Egypt, 1963

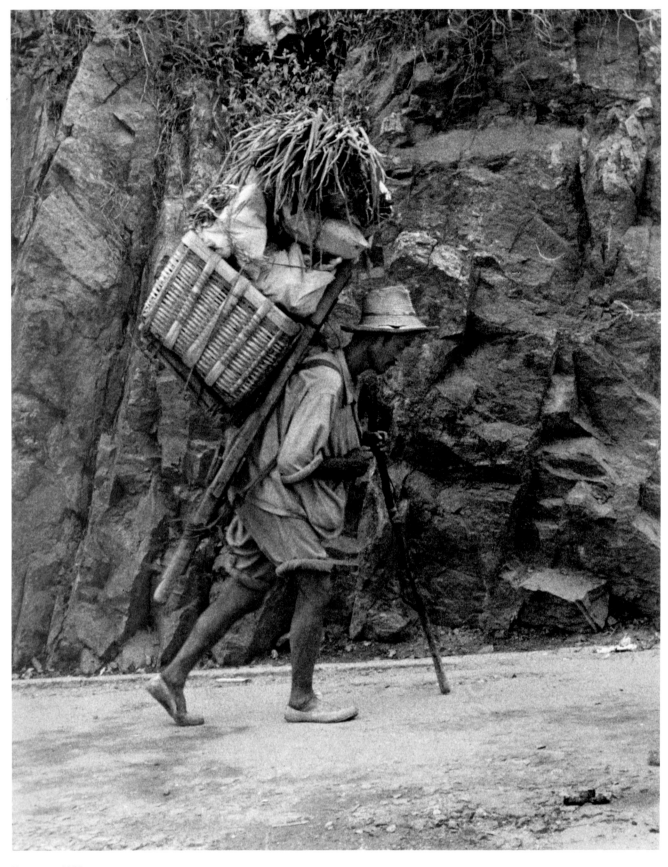

Korea, ca. 1958

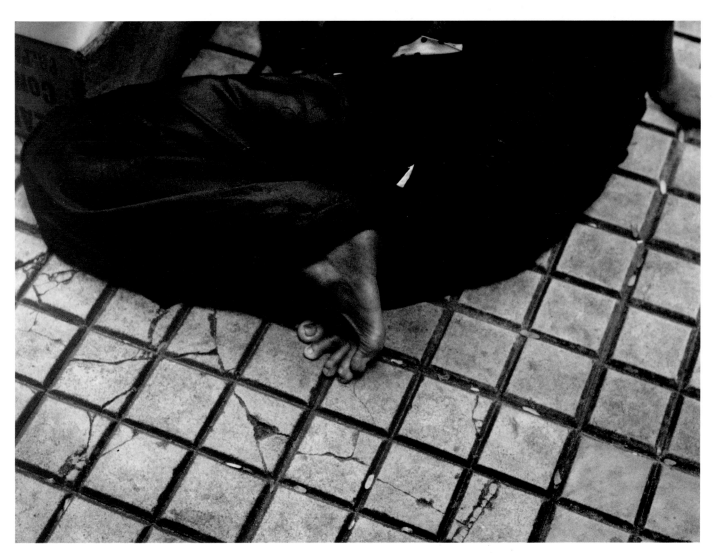

Woman's Foot, Vietnam, 1958

"*I was physically disabled, and no one who hasn't
lived the life of a semi-cripple knows how much that
means. I think it perhaps was the most important
thing that happened to me, and formed me, guided
me, instructed me, helped me, and humiliated me.
All those things at once.*"

"The dancers moved and passed as though in a trance. Endless, timeless..., distilled in elegance, control and beauty. The individual obliterated in the form it developed, and consecrated to it."

Indonesian Dancer, Java, 1958

"I very early remember that my grandmother told me that of all the things that were beautiful in the world there was nothing finer than an orange... She said this to me as a child, and I knew what she meant, perfectly."

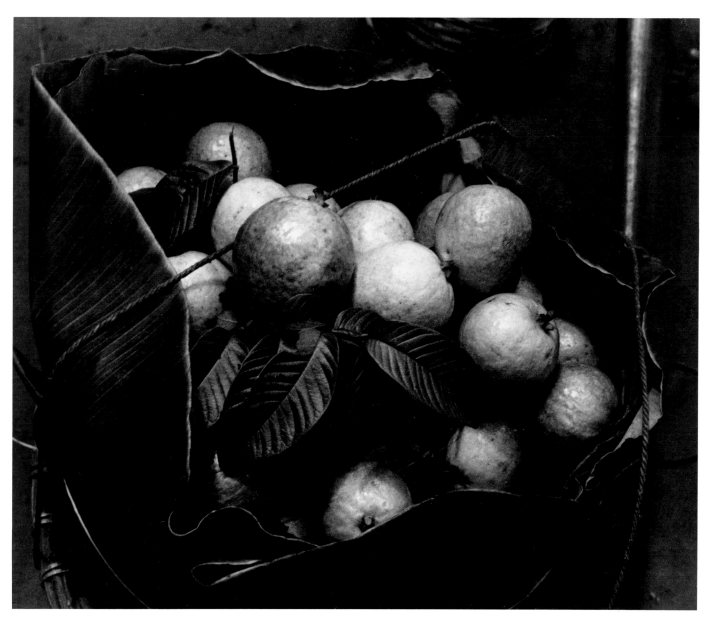

Saigon Market, 1958

"One should really use the camera as though tomorrow he would be stricken blind. Then the camera becomes a beautiful instrument for the purpose of saying to the world in general: 'This is the way it is. Look at it! Look at it!'"

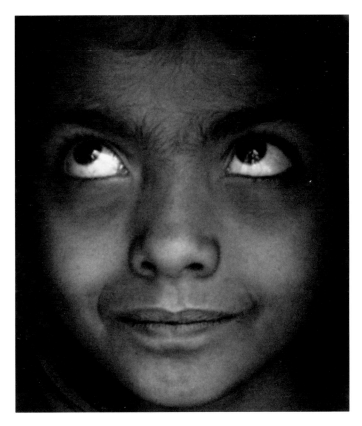

Palestinian Child, 1958

"Durer said, 'I draw from the secrets of my heart.'
And that's what I have, in the end. That's what it
comes to and that's best. Provided, of course, you've
got an educated heart and a sense of some kind of
general responsibility. The secret places of the heart
are the real mainsprings of one's actions."

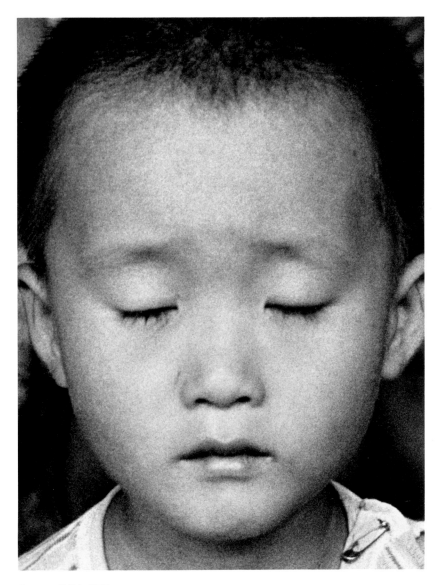

Korean Child, 1958

Chronology

1895

Dorothea Margaretta Nutzhorn born May 25 in Hoboken, N.J., to Henry and Joanna (Lange) Nutzhorn.

1901

Dorothea's brother, Henry Martin Nutzhorn, born.

1902

Dorothea is stricken with poliomyelitis, resulting in an impaired right leg and a lifelong limp.

1907

Henry Nutzhorn abandons his family, forcing them to live with a grandmother and aunt in Hoboken. This begins a difficult and lonely time for Dorothea, who feels alienated at home and school. She becomes a frequent truant, spending time walking in the park, visiting museums, and attending free concerts. She often wanders through the Bowery, learning to observe life without drawing attention to herself, a practice she later feels prepared her to be a documentary photographer.

1913-14

Upon graduation from high school, Lange declares her intention to become a photographer. Since she has not previously owned or used a camera, the family insists that she attend the New York Training School for Teachers in order to "have something to fall back on." While taking day classes, her spare time is spent working in several commercial portrait studios in Manhattan, including that of Arnold Genthe. She works as a receptionist while learning to spot, retouch, and mount prints. Lange leaves school after an unsuccessful practice teaching experience.

1915-16

Lange gains further knowledge of the commercial portrait business by working in the studios of Aram Kazanjian and A. Spencer-Beatty.

1917

Beginning in February, Lange attends a basic photography seminar taught by Clarence H. White at Columbia University.

1918

With her friend Florence Ahlstrom, Lange leaves New York on a proposed trip around the world. The journey ends in San Francisco, where they lose their money to a pickpocket. Finding employment as a photo-finisher, Lange joins a camera club and meets local photographers such as Imogen Cunningham and Consuela Kanaga. Upon settling in San Francisco, she formally assumes her mother's maiden name, Lange.

1919

Lange opens her own portrait studio at 540 Sutter Street, and quickly achieves success by catering to the city's most prominent families. She meets Maynard Dixon, a noted artist and illustrator.

1920

On March 21, six months after their first meeting, Lange and Dixon are married.

1921

Dixon ceases most of his commercial work to devote himself to painting. The family travels to the High Sierras on one of Dixon's many sketching trips.

1922

In the summer, Dixon and Lange visit a Navajo reservation in Arizona; she photographs while he sketches.

1923

To promote Dixon's work, the couple travel to Chicago and New York. In the summer they visit Navajo and Hopi country with a wealthy friend and patron, Anita Baldwin McClaughry.

1925

Lange's first son, Daniel Rhodes Dixon, is born on May 15.

1928

Lange's second son, John Eaglefeather Dixon, is born on June 12.

1929

Lange and Dixon make an extended trip to Arizona. They return to San Francisco in the fall, just after the crash of the stock market in late October.

1930

The Dixon boys are sent to live with a family in Watsonville, where they remain through most of the Depression.

1931

The family spends seven months in Taos, New Mexico; Dixon paints while Lange photographs.

1932

Their commissions both affected by the Depression, Lange and Dixon save money by residing apart in their respective studios. Moved by the social upheaval around her, Lange begins photographing the breadlines and unemployed of San Francisco.

1933

Lange documents the May Day demonstrations at San Francisco's Civic Center. In the summer, the family travels to Utah.

1934

Lange gives up her studio, continuing her portrait business from their new home at 2515 Gough Street. Willard Van Dyke exhibits Lange's documentary photographs at his studio at 683 Brockhurst, in Oakland, and writes an insightful essay on her work for *Camera Craft* magazine. Paul S. Taylor, an economics professor at the University of California-Berkeley, sees this exhibition and contacts Lange to obtain photographs for reproduction in *Survey Graphic*.

1935

Beginning in February, Lange works with Taylor on the staff of California's State Emergency Relief Administration (S.E.R.A.) photographing impoverished migrants throughout the state. Because there is no provision for a photographer in the budget, Lange is listed as a "clerk-stenographer." In the summer, Roy Stryker is made Chief of the Historical Section of the newly created Resettlement Administration (R.A.) in Washington, D.C. Impressed by Lange's work, Stryker has her transferred from the S.E.R.A. to the R.A. By the end of the year, Stryker's photographic staff includes Lange, Arthur Rothstein, Ben Shahn, Walker Evans, and Carl Mydans. A personal relationship develops between Taylor and Lange; they divorce their former spouses and are married in December.

1936

In the first months of the year, Lange photographs migrant conditions and R.A. rehabilitation projects in California and Utah. In March, she makes *Migrant Mother* in a peapickers camp in Nipomo, California. After Taylor is transferred to the Social Security Board, he and Lange travel east to Washington, D.C., and New York City. Lange photographs through the South before returning to California in August. In October, she is temporarily dropped from the R.A. payroll due to federal budget cuts.

1937

Lange is rehired by the R.A. in January; her first project is to select photographs to illustrate a Senate report on migratory labor. In May, she and Taylor begin an extended documentation of tenancy in the South and Southwest. The R.A. is placed under the authority of the Department of Agriculture and renamed the Farm Security Administration (F.S.A.). At the end of the year, Lange is again cut from Stryker's payroll.

1938

Before reinstatement on the F.S.A. staff in late September, Lange works on her own, photographing in California, the West, and South. In October, she records government camps and F.S.A. projects in southern California. Following the success of photo-books such as Archibald MacLeish's *Land of the Free* (which reproduces 33 Lange images), Lange and Taylor begin work on their own picture-text collaboration, *An American Exodus*. Lange's pictures are included in an F.S.A. exhibition in New York City, and a major portfolio in *U.S. Camera* magazine.

1939

Lange travels through California to record the expansion of mechanized agriculture. Later in the year, she photographs in North Carolina and the Northwest. John Ford, directing the film based on John Steinbeck's new book *The Grapes of Wrath*, uses Lange's photographs as primary research material. *An American Exodus* is published at the end of the year.

1940

On January 1, Lange is dropped from the F.S.A. payroll for the final time. In February, she is made Head Photographer of the U.S. Department of Agriculture's Bureau of Agricultural Economics (B.A.E.), and works in California and Arizona. She begins to suffer from recurrent illnesses, including ulcers.

1941

Lange receives a Guggenheim Fellowship to photograph cooperative communities in the U.S.: the Hutterites in South Dakota, the Amana society in Iowa, and the Mormons in Utah. She begins, but does not complete, this project.

1942

In April, Lange begins work for the War Relocation Administration (W.R.A.) documenting the evacuation of West Coast Japanese-Americans to internment camps. She records the assembly centers in northern California and life in the Manzanar Camp in Owens Valley.

1943-44

Lange photographs for the Office of War Information, recording California's minority groups for various O.W.I magazines. Most of the negatives for this work are subsequently lost. In collaboration with Ansel Adams, she completes a photo-essay for *Fortune* magazine on the World War II boom town of Richmond, California.

1945

In the spring, Lange photographs the United Nations conference in San Francisco. Following this project, she ceases photography for several years due to illness.

1949

Eight of Lange's pictures are included in the Museum of Modern Art's exhibition "Sixty Prints by Six Women Photographers."

1951

Lange begins actively photographing again. In the fall, she participates in a major photography conference at Aspen, Colorado.

1952

Lange helps found *Aperture* magazine; with her son, Daniel Dixon, she contributes the article "Photographing the Familiar" to the journal's second issue. The Museum of Modern Art's exhibition "Diogenes with a Camera II" includes 36 Lange prints. She begins promoting a F.S.A.-style documentary project for contemporary photographers; this eventually develops into her proposal "Project One."

1953

With Ansel Adams and Daniel Dixon, Lange works in Utah on the photoessay "Three Mormon Towns" for *Life* magazine.

1954

With Daniel Dixon, Lange works on the photoessay "The Irish Country People" for *Life*. Lange assists Edward Steichen in reviewing West Coast work for Steichen's upcoming "The Family of Man" exhibition at the Museum of Modern Art.

1955

Lange attends the opening of "The Family of Man," which includes 9 of her pictures. During the spring, she begins her "Public Defender" project, a study of the California judicial system focussing on a young lawyer named Martin Pulich. She acquires a cabin at Steep Ravine, twenty miles north of San Francisco, where she spends weekends with her family in the following years.

1956-57

In collaboration with Pirkle Jones, Lange works on a photoessay, "Death of a Valley," documenting the destruction of the Berryessa Valley, in northern California, to make way for a reservoir. *Life* expresses an initial interest in the story but does not use it.

1957

In the spring, Lange teaches a seminar titled "Where Do I Live?" at the California School of Fine Arts (now the San Francisco Art Institute).

1958-59

Lange accompanies Taylor, who is working as a government economics consultant, on an extended trip through Asia and Europe. She photographs intermittently in Korea, Japan, Hong Kong, Thailand, Singapore, Rangoon, Calcutta, Nepal, Germany, and England.

1960

Lange accompanies Taylor, now working for the United Nations Social Welfare Division, to South America. Two months are spent in Ecuador and Venezuela.

1961

A one-person exhibition of Lange's images of rural American women is mounted at the Carl Siembab Gallery in Boston.

1962

Lange's work is featured in several exhibitions, including the Museum of Modern Art's survey of F.S.A. photography, "The Bitter Years." Plagued by ulcer problems, Lange is unable to photograph and spends much of the year in the hospital. By December, she feels well enough to join Taylor in Egypt, where he is engaged as a visiting professor at the University of Alexandria.

1963

Lange photographs intermittently in Egypt in difficult conditions. She and Taylor leave in June; during a visit to Iran she becomes seriously ill with malaria. After recuperating in Switzerland, the two visit Holland and then fly home in September.

1964

In February, John Szarkowski, the newly appointed director of the Museum of Modern Art's department of photography, proposes a major career retrospective to open on January 25, 1966. With her assistant, Richard Conrat, Lange begins reviewing her life's work and selecting images for the exhibition. In April, she drafts a proposal for "Project One" and travels to Washington, D.C., and New York City to promote the concept. In August, she is diagnosed with inoperable cancer of the esophagus. Szarkowski visits in December to discuss the content and layout of her retrospective.

1965

Work prints for the Museum of Modern Art retrospective are completed in April and sent to New York. During the summer, Lange finishes organizing a collection of portraits of rural women, published posthumously as *Dorothea Lange Looks at the American Country Woman* (1967). Szarkowski visits in August to discuss the final details of the exhibition. On September 30, overcome with fever, she is admitted to a San Francisco hospital. Lange's health rapidly declines, and on October 11 she dies of cancer.

Bibliography

PRIMARY COLLECTIONS

Farm Security Adminstration Collection, Prints and Photographs Division, Library of Congress, Washington, D.C. This file contains some 4,000 catalogued photographs made during Lange's work for the Resettlement Administration and the Farm Security Adminstration between January 1935 and October 1939. Many of her most memorable Depression-era photographs are contained in this collection.

The Dorothea Lange Collection, Oakland Museum, Oakland, California. The largest Lange archive, this collection contains many study prints, about 40,000 negatives, and a wide variety of papers, including field notes, correspondence, and journals.

ARTICLES AND INTERVIEWS
(listed chronologically)

Willard Van Dyke, "The Photographs of Dorothea Lange: A Critical Analysis," *Camera Craft* 41(October 1934): 461-67. This insightful article represents the earliest serious criticism of Lange's mature work. Van Dyke organized the first exhibition of Lange's documentary photographs, in the summer of 1934, at his 683 Brockhurst Gallery.

Dorothea Lange and Ansel Adams, "Richmond Took a Beating," *Fortune* 31(February 1945): 262-69. This collaborative photoessay records the activities and changes in the World War II boom town of Richmond, California.

Dorothea Lange and Daniel Dixon, "Photographing the Familiar," *Aperture* 1:2(1952): 5-15. In this revealing essay, Lange assesses the state of contemporary photography and clearly articulates her vision of the medium's potential.

Daniel Dixon, "Dorothea Lange," *Modern Photography* 16(December 1952): 68-77, 138-41. This biographical sketch, written by her son, sheds light on Lange's photographic philosophy and working methods.

Dorothea Lange and Ansel Adams, "Three Mormon Towns," *Life* (September 6, 1954): 91-100. In this photoessay, Lange and Adams document the texture of Mormon life in the Utah towns of St. George, Gunlock, and Toquerville.

Dorothea Lange, "The Irish Country People," *Life* (March 21, 1955): 135-43. In this photoessay, Lange sought to convey "a portrait of the country itself, its population, its customs, its mores, its atmosphere, the texture of its life."

Dorothea Lange, "The Assignment I'll Never Forget," *Popular Photography* 46(February 1960): 42-43, 128. The circumstances surrounding the making of Lange's most famous photograph, *Migrant Mother*, 1936, are recounted here.

Dorothea Lange and Pirkle Jones, "Death of a Valley," *Aperture* 8:3(1960): 127-65. This lengthy collaborative photoessay documents the destruction of Northern California's Berryessa Valley.

Nat Herz, "Dorothea Lange in Perspective," *Infinity* 12(April 1963): 5-11. In this interview, Lange discusses her feelings about photography as a medium of artistic expression.

Dorothea Lange, "Remembrances of Asia," *Photography Annual 1964* (New York: Ziff-Davis, 1963): 50-59, 191, 193. This article reproduces photographs made in Lange's travels in the Far East in 1958-59.

Jacob Deschin, "This Is the Way It Is— Look at It! Look at It!" *Popular Photography* (May 1966): 58-60. This profile is based on an interview with Lange at the end of her life.

Dorothea Lange: The Making of a Documentary Photographer, An Interview Conducted by Suzanne Riess (Berkeley: Regional Oral History Office, Bancroft Library, University of California, Berkeley, 1968). In this lengthy interview, conducted in 1960-61, Lange recounts the major events of her personal and professional life.

James Curtis, "Dorothea Lange, *Migrant Mother* and the Culture of the Great Depression," *Winterthur Portfolio* 21(Spring 1986): 1-20. In this fascinating article, Curtis closely examines the circumstances surrounding the making of Lange's iconic image, *Migrant Mother*.

BOOKS AND MONOGRAPHS
(listed chronologically)

Dorothea Lange and Paul Schuster Taylor, *An American Exodus: A Record of Human Erosion* (New York: Reynal & Hitchcock, 1939). As Lange's first major publication, this collaborative effort unites photographs and text to document the social and economic upheaval of rural America in the late 1930s. It was republished, in a significantly revised edition, in 1969 by Yale University Press.

George P. Elliott and John Szarkowski, *Dorothea Lange* (New York: Museum of Modern Art, 1966). The catalogue for Lange's 1966 MoMA retrospective, this publication provides a good, concise overview of her career. It includes an insightful and sympathetic introduction by Elliott, and a bibliography and chronology.

Dorothea Lange, *Dorothea Lange Looks at the American Country Woman* (Fort Worth: Amon Carter Museum, 1967). Although issued posthumously, this collection of photographs and captions was designed by Lange in the last years of her life. The foreword is by her friend Beaumont Newhall.

Maisie Conrat and Richard Conrat, *Executive Order 9066: The Internment of 110,000 Japanese Americans* (Los Angeles: California State Historical Society, 1972). Lange's images of 1942 are used extensively in this catalogue, which was coedited by her former assistant, Richard Conrat.

Dorothea Lange and Margaretta Mitchell, *To a Cabin* (New York: Grossman, 1973). Completed by Mitchell after Lange's death, this publication is composed of family photographs made in the final years of her life.

William Stott, *Documentary Expression and Thirties America* (New York: Oxford University Press, 1973). This important and influential work of cultural history considers Lange's photography, and her book *An American Exodus*, at some length.

Hank O'Neal, *A Vision Shared: A Classic Portrait of America and Its People, 1935-1943* (New York: St. Martin's Press, 1976). A fine introduction to the work of the F.S.A., with portfolios by each of the group's photographers.

Therese Thau Heyman, *Celebrating a Collection: The Work of Dorothea Lange* (Oakland: Oakland Museum, 1978). This valuable catalogue functions as a guide to the Oakland Museum's large collection of Lange's photographs and papers. It includes a selected bibliography, and essays on various aspects of Lange's work by Heyman, Paul Schuster Taylor, Daniel Dixon, and Joyce Minick.

Milton Meltzer, *Dorothea Lange: A Photographer's Life* (New York: Farrar Straus Giroux, 1978). The most comprehensive study of Lange's career, with numerous reproductions and a detailed bibliography.

Karin Ohrn, *Dorothea Lange and the Documentary Tradition* (Baton Rouge: Louisiana State University Press, 1980). A valuable study of Lange's work, which places her in the larger context of the documentary photography of her time. A variety of prints and contact sheets are reproduced, and a comprehensive bibliography is included.

Howard M. Levin and Katherine Northrup, eds., *Dorothea Lange: Farm Security Adminstration Photographs from the Library of Congress, 1935-1939*, vols. I and II (Glencoe, Ill.: The Text-Fiche Press, 1980). These volumes provide microfiche reproductions of 1,311 of Lange's F.S.A. photographs with definitive caption information, as well as valuable texts by Paul Schuster Taylor and Robert J. Doherty, and excerpts of interviews with Lange by Suzanne Riess and Richard K. Doud.

Robert Coles, *Dorothea Lange: Photographs of a Lifetime* (Millerton, N.Y.: Aperture, 1982). This extensive collection of Lange photographs is augmented by a biographical essay by Coles, a chronology, bibliography, and an afterword by Therese Thau Heyman.

Andrea Fisher, *Let Us Now Praise Famous Women* (London: Pandora, 1987). Fisher documents the contributions of women photographers of the F.S.A. period, including Lange.

Carl Fleischhauer and Beverley W. Brannan, eds., *Documenting America, 1935-1943* (Berkeley: University of California Press, 1988). A fine introduction to the photography of the F.S.A. era, with essays by Lawrence W. Levine and Alan Trachtenberg, and representative photoessays by fifteen photographers, including Lange.

James Curtis, *Mind's Eye, Mind's Truth: F.S.A. Photography Reconsidered* (Philadelphia: Temple University Press, 1989). Curtis explores the complex nature of F.S.A. photography by close analysis of the work of Walker Evans, Arthur Rothstein, and Lange.

Elizabeth Partridge, ed., *Dorothea Lange: A Visual Life* (Washington: Smithsonian Institution Press, 1994). This book surveys various facets of Lange's life, as a photographer, friend, mother, and activist. Included are sensitive and insightful essays by Linda A. Morris, Clark Kerr, Roger Daniels, Sally Stein, Therese Thau Heyman, and Daniel Dixon.

Therese Thau Heyman, Sandra S. Phillips, and John Szarkowski, *Dorothea Lange: American Photographs* (San Francisco: Chronicle Books, 1994). This amply illustrated monograph, published to accompany a Lange retrospective organized by the San Francisco Museum of Modern Art, focuses on her work in the U.S. of the 1930s-50s. Valuable essays are included by each of the three authors.

Notes and Sources

Notes on the photographs and texts included in this volume are provided below. The reproductions were made from Lange prints in the Hallmark Photographic Collection; the image size of these prints is given in inches. Vintage prints are indicated "v"; all others were probably printed some time after the date of the negative. Some ambiguity exists on the precise date and subjects of some of Lange's photographs; a few of these uncertainties are discussed below.

The textual excerpts used in this volume are of three types: Lange's own words, drawn from interviews or her writings (indicated in Palatino italic, within quotation marks); the words of her subjects (indicated in Palatino roman, within quotation marks); and factual data, usually drawn from Lange's field notes (indicated in Frutiger). Many of these quotations and excerpts are from the following sources, which are abbreviated as noted:

Dorothea Lange and Paul S. Taylor, *An American Exodus: A Record of Human Erosion* (New York: Reynal & Hitchcock, 1939) [*Exodus*].

Dorothea Lange: The Making of a Documentary Photographer: An Interview Conducted by Suzanne Riess (Berkeley: Regional Oral History Office, Bancroft Library, University of California, 1968) [Riess].

George P. Elliott and John Szarkowski, *Dorothea Lange* (New York: Museum of Modern Art, 1966) [MoMA].

Daniel Dixon, "Dorothea Lange," *Modern Photography* (December 1952): 68-77, 138-41 [*Modern*].

Daniel Dixon and Dorothea Lange, "Photographing The Familiar," *Aperture* 1:2(1952): 4-15 [*Aperture*].

Nat Herz, "Dorothea Lange in Perspective," *Infinity* (April 1963): 5-11 [Herz].

Dorothea Lange Looks at The American Country Woman (Fort Worth: Amon Carter Museum, 1967) [*ACW*].

Howard M. Levin and Katherine Northrup, eds., *Dorothea Lange: Farm Security Administration Photographs, 1935-1939, from the Library of Congress*, vols. I and II (Glencoe, Illinois: The Text-Fiche Press, 1980) [LoC].

Pages

1: "The camera...," cited in Milton Meltzer, *Dorothea Lange: A Photographer's Life* (New York: Farrar Straus Giroux, 1978), xv.

2: 4½ x 4½" (v).

11: "For me...," *Modern*, p. 68.

12: "I was...," from Lange interview with Richard K. Doud, as published in LoC, vol. II, pp. 56-57.

13: 4⅝ x 3½".

14: 2 x 2" (v).

15: 7⅜ x 6¼" (v).

16: "We went...," Riess, p. 126.

17: 7 x 6½" (v).

18: "That period...," Riess, pp. 137-41. "There in...," composite of versions of same story published in Riess, pp. 144-45; Herz, p. 9; and *Modern*, p. 75.

19: 4⅝ x 3⅝" (v).

20: 12¾ x 10½". "There are...," Herz, p. 9.

21: 11⅝ x 10" (v).

22: "I realize...," Riess, p. 156; "I assigned...," Riess, pp. 149-50.

23: 9½ x 7⅛" (v). The date of this image, usually given as 1934, is in some question. Sandra Phillips suggests that the picket signs and policeman's uniform mark this as a work of 1938 (Heyman, et al., *Dorothea Lange: American Photographs* [San Francisco: San Francisco Museum of Modern Art/Chronicle Books, 1994], p. 39, footnote 47). A possible variant negative of this subject is dated August 1936 in LoC, vol. I, p. 180 (image 6-65). The date of 1933 is taken from the example of this image in the Hallmark Photographic Collection: a vintage exhibition print that is signed and dated on the mount in Lange's hand.

25: 8¾ x 6⅞" (v).

26: 9¼ x 7¼" (v).

27: 9⅛ x 6⅞" (v).

29: 7¼ x 6⅝" (v). While this photograph has often been dated 1934, this vintage, mounted exhibition print is signed and (twice) dated 1933 in Lange's hand.

30: "By then...," *Modern*, p. 75.

31: 9½ x 10", printed ca. 1951 for inclusion in Museum of Modern Art's "Diogenes With a Camera II" exhibition of 1952.

32: 9¼ x 7" (v).

33: 7¾ x 7⅜" (v).

34: 9¼ x 7" (v).

35: 8⅜ x 5⅛" (v).

36: "The country's...," *Exodus*, p. 35.

37: 7 x 9⅜" (v); "They keep...," *Exodus*, p. 65.

38: 2⅞ x 3¾" (v). The movement of colonists from northern Minnesota to Alaska in the spring of 1935 was an attempt at an ordered resettlement of distressed people. Lange, working for the Division of Rural Rehabilitation, California Emergency Relief Administration, recorded the initial contingent of sixty-seven families as they sailed from San Francisco on May 1, 1935. Matanuska was later renamed Palmer, Alaska. "No, I didn't...," *Exodus*, p. 99. "Example of...," LoC, vol. I, p. 137, image 2-39.

39: 9½ x 7⅝" (v).

40: 6⅛ x 9⅛" (v). On the reverse of this mount is written: "Field work for Rural Rehabilitation Division of State Relief Administration."

41: 7¼ x 9¼" (v). This print, mounted on a piece of spiral-bound board, was originally in one of Lange's hand-made albums. The full title ("I don't...") is inscribed in Lange's hand on the mount directly below the image. "People just...," *Exodus*, p. 109.

42: 8⅞ x 6⅝" (v); "I had...," *Modern*, p. 76.

43: 10½ x 13⅞ (v); descriptive text, LoC, vol. I, p. 138, image 2-51.

44: Letter from Lange to Roy Stryker, from photocopy in Oakland Museum collection. Text from LoC, vol. I, p. 135, image 2-31.

45: 13⅜ x 10¼.

46: Text from Heyman, et al., *Dorothea Lange: American Photographs*, plate 47.

47: 7¼ x 9¼" (v).

48: 6¾ x 9⅛" (v); text from LoC, vol. I, p. 147, image 3-56.

49: 8½ x 11⅞" (v); "Their roots...," *Modern*, p. 138.

51: 7½ x 9½".

52: 12½ x 10⅜".

53: 10¼ x 13"; "Grayson was...," "Lange's notes, as published in MoMA, p. 104.

54: "We want...," unnamed Delta farm-hand, as quoted by Robert Coles in essay in *Dorothea Lange: Photographs of a Lifetime* (Millerton, N.Y.: *Aperture*, 1982), p. 29.

55: 10¼ x 13¼"; text from MoMA, p. 103.

56: 7¼ x 9⅜" (v); text from Oakland Museum records.

57: 10½ x 13½"; text from Oakland Museum records.

58: "These are...," *ACW*, p. 13. Text from LoC, vol. I, p. 162, image 5-18.

59: 13¼ x 10⅜".

60: 7⅞ x 7¼" (v); text from LoC, vol. I, p. 181, image 6-82. Note that while this source dates this image January 1938, the file of this series of negatives in the Oakland Museum collection is dated 1937.

61: 7⅞ x 7½" (v); text from FSA files, Library of Congress.

62: "Everything is...," Riess, p. 181.

63: 7¾ x 9¼".

64: 9⅝ x 7¼" (v); text from LoC, vol. I, p. 200, image 8-78.

65: 7½ x 9½" (v). "Earlier...," *Modern*, p. 138.

66: 10½ x 13½".

67: 8½ x 10⅝".

69: 9¼ x 7½". This image has been published with dates of both 1937 and 1938.

70: "My father...," LoC, vol. I, pp. 205-06, image 9-44. Note that this photograph has been widely published (beginning with *Exodus*, pp. 130-31) under the title "Ma Burnham." It seems likely that Lange and Taylor chose this pseudonym to shield the identity of the sitter.

71: 13⅞ x 11".

72: 10⅜ x 10⅞".

73: 9¼ x 13⅜"; text from *Exodus*, p. 73.

74: Text from *Exodus*, p. 76.

75: 10½ x 13⅜".

76: 9¾ x 8⅞", print made ca. 1951 and included in MoMA exhibition "Diogenes with a Camera II," 1952.

77: 9⅝ x 7⅝" (v).

78: 7¾ x 9⅜"; text from Lange's field notes for a related series of images (of annual clean-up day at church on July 5, 1939, four days before *The Congregation Gathers* was taken), as published in *ACW*, p. 71.

79: 9¼ x 11¾".

80: "What I photographed...," Riess, pp. 185-88. Text from Lange's notes, as published in MoMA, p. 104.

81: 13⅜ x 10⅛" (v).

82: 10⅜ x 9"; "These people...," Riess, pp. 187-92.

83: 10⅜ x 13¼" (v).

85: 13¼ x 9⅜" (v).

86: 7¾ x 7⅝" (v).

87: 7⅝ x 9⅝" (v); text from Lange's notes, as published in MoMA, p. 104.

88: 8⅞ x 7⅛" (v).

89: 7⅝ x 7½" (v); Lange's text inscribed directly on lower margin of print.

90: (top): 11⅜ x 10⅜" (v); (lower): 6⅛ x 9⅜". "I find...," excerpt, letter from Lange to Beaumont Newhall, as published in *ACW*, p. 9.

91: 8¼ x 6" (v).

92: 15⅛ x 15" (v).

93: 9⅛ x 6⅜" (v).

94: "Documentary Photography...," Dorothea Lange in T.J. Maloney, G.M. Morley, and Ansel Adams, eds., *A Pageant of Photography* (San Francisco: Crocker Union, 1940), p. 28.

95: 12⅛ x 9¾" (v).

96: 9½ x 7⅝" (v).

97: 7¾ x 9⅛" (v).

99: 9⅛ x 7⅝" (v).

101: 6⅞ x 9⅛" (v).

102: "[The photographer…," excerpts from *Aperture*, pp. 8-15. Text from *ACW*, p. 40.

103: 9⅜ x 7⅜".

104: (top): 12¼ x 10⅞" (v); text from *ACW*, p. 44; (lower): 6½ x 9½" (v).

105: 7⅛ x 7⅜" (v).

107: 9¾ x 7⅜" (v).

108: 7¾ x 9⅜" (v); the subject is Lange's friend Christina Gardner.

109: 10½ x 13½" (v).

110: "In the past…," *Modern, p. 141.*

111: 6 x 4¾" (v).

112: "I'm always…," from film script for "Dorothea Lange: A Visual Life," Meg Partridge, Pacific Pictures, Valley Ford, California, p. 19, as cited in Elizabeth Partridge, ed., *Dorothea Lange: A Visual Life* (Washington, D.C.: Smithsonian Institution Press, 1994), p. 134. "It's a very…," Riess, pp. 177-78.

113: 7½ x 9½" (v).

114: 13⅛ x 10⅜" (v).

115: 9⅝ x 13" (v). "I was…," Riess, p. 17.

116: "The dancers…," undated [November 1958] entry in Lange's notebook, Oakland Museum.

117: 8⅛ x 7" (v).

118: "I very early…," Riess, p. 1.

119: 10⅛ x 12¼" (v).

120: "One should…," quoted in Jacob Deschin, "'This is The Way It Is—Look at It! Look at It!'," *Popular Photography* (May 1966): 58.

121: 4⅛ x 3⅝" (v). This image has also been published under the title *Karachi, Pakistan.*

122: "Durer said…," Riess, p. 216.

123: 5¾ x 4⅜" (v).